Applied Infrared Photography

CONTENTS

Applied infrared photography with black-and-white or false color materials offers intriguing variety and potential value in a wide range of fields. Applications include water pollution study from the air, timber resources surveys, the infrared luminescence of coals, dramatic pictorial derivations, study of painters' methods, revealing the text of ancient scrolls, exposing forged documents, and picturing the nocturnal flight of bats. Whatever the ultimate purpose of the photographs, infrared photography provides information unobtainable by other means.

Simply stated, infrared photography is the recording of images formed by infrared radiation. Because infrared radiation is invisible, some special techniques may be needed. But in general, most of the commonly required methods are as simple as those of ordinary photography.

1977 EDITION, 1981 PRINTING

IN THIS EDITION

Applications of infrared photography continue to increase in spite of the current emphasis on electronic thermography. On the covers of this edition, we show two recent applications of color infrared photography. Explained in the text are the differences between direct recording of infrared radiation on film and indirect recording via a cathode-ray tube image produced by electronic detection of long wavelength infrared radiation. Included in this edition is data on film handling, exposure recommendations, and flash guide numbers for infrared films.

Standard Book Number 0-87985-288-7
Library of Congress Catalogue Number 81-65754
© Eastman Kodak Company, 1981

UNDERSTANDING INFRARED PHOTOGRAPHY

This book classifies numerous outdoor and indoor techniques for photography by infrared radiation. The purposes of the various methods and the procedures involved are described. Certain applications and techniques are beyond the scope of this book; nevertheless, key references are given for those who wish to do further study. References are listed in all the fields covered. Data on film characteristics, filters, light sources,, and processing are also included.

Thermal recording is an indirect infrared photographic technique and is described briefly. The differences between it and infrared photography should be realized, because it is an entirely different technique.

ELECTROMAGNETIC RADIATION

It will be helpful first to define various kinds of electromagnetic radiation and then to consider infrared that falls in the region of the spectrum to which film is sensitive. This actinic radiation can be photographed with a camera. On the other hand, there are thermal infrared regions that cannot themselves be recorded by photographic means.

The Visible Spectrum

A beam of white light can be dispersed by a glass or a crystal prism into a spectrum; this includes a band of color ranging from violet through blue, blue-green, green, yellow, orange, red, and deep red. The colors of the visible spectrum are familiar; we see them in the rainbow, which is a result of the dispersion of white light by raindrops. The colors are separated because they represent light of different wavelengths. These wavelengths become longer as the spectrum is traversed from blue to red. The range of wavelengths covered by the visible spectrum is from about 400 nm at the blue end to about 700 nm at the extreme-red end. (See the diagram in Figure 1.)

The wavelengths are denoted here in terms of nanometres (nm), which is one millionth of a millimetre. In some published literature, the term *millimicron (mμ) is used with the same meaning as nanometre.*

The Invisible Spectrum

In addition to the light which we can see, there also exists invisible electromagnetic radiation similar to the visible radiation called light. Invisible radiation manifests itself at both ends of the visible spectrum. Beyond the violet is radiation which is called the ultraviolet, and which is of relatively short wavelength. It is invisible but has strong action on photo-

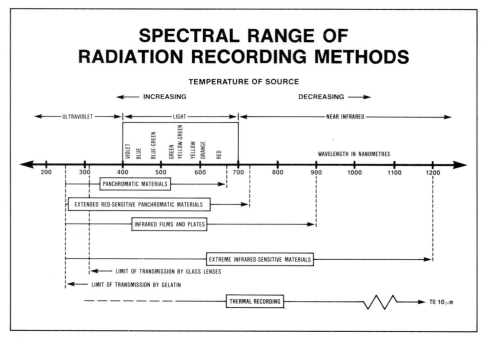

FIGURE 1—The photographically actinic regions of the electromagnetic spectrum.

graphic materials, making it easy to detect by photographic means. At the other end of the spectrum, at wavelengths longer than the red, there exists the infrared, meaning "below the red."

As the infrared region extends far beyond the end of the visible region, the wavelength increases. The radiation merges into heat waves, and finally into radar and radio waves. Even though the infrared extends far out, it is only the region quite near the visible red that is photographically actinic. The longest wavelength of radiation recorded by photography is about 1350 nm, but in the general infrared work dealt with in this book, the region between 700 nm and 900 nm is used.

It can be seen that photographic emulsions are especially sensitized to record only the near infrared spectrum. Beyond this range, storage and use of a specialized film would be impractical because of radiated heat. Even warmth at about body temperature, in the camera and the surroundings, would fog the film. For some applications now served by thermal recording, such specialized film, even if it could be made, would have to be stored and used at the low temperature of liquid nitrogen.

Infrared radiation can be separated into four broad ranges of increasingly longer wavelengths: (1) The actinic range, which comprises the near-red part of the radiation produced by incandescent objects, such as the sun or a lamp filament. (2) The hot-object range; this radiation comes from nonincandescent subjects, such as heated flatirons or an electrical component, having temperatures around 400°C. (3) The calorific range; this radiation is produced by objects with temperatures around those of boiling water and steam pipes (below about 200°C); it is nonactinic. (4) The warm range; the human body and warm ground radiate in this range; it also is nonactinic. When it is realized that the wavelength of radiation in this category is around 9000 nm, it will be appreciated why recording such radiation on film is impossible. Holter (1967) offers a good outline of the particulars involved.

RECORDING METHODS AVAILABLE

Techniques fall into two broad categories: those employing infrared film, and those involving complex auxiliary equipment which produces an image that can be photographed on ordinary film. This book deals mainly with the former, but also presents the distinction between the two.

Film Recording

Black-and-White Infrared Photography: Regular infrared photography can be defined as the technique of using a camera lens to focus an infrared image onto an emulsion sensitized to infrared radiation so as to obtain a black-and-white negative record, and subsequently a positive print. The subject producing the image emits, reflects, or transmits varying amounts of the infrared radiation falling on it, or emits *luminescence** in the infrared region when illuminated with visible light. The lights commonly used for ordinary photography supply or excite the infrared radiation for indoor reflection, transmission, and emission techniques. Sometimes, however, the subject is hot enough to emit actinic infrared itself. Outdoors, sunlight furnishes adequate infrared, but the intensity is somewhat variable because of haze and cloud cover.

Infrared emulsions are sensitive to violet, blue, and red light as well as to infrared. Therefore, a filter has to be used over the camera lens (or sometimes the light source) to block unwanted visible light rays. This filter passes the infrared radiation coming from the subject and excludes visible light and ultraviolet.

Infrared luminescence is caused by illuminating the object with relatively long wavelength radiation (visible blue or green) which the object re-emits at longer wavelengths (infrared radiation). Thus, these wavelengths are *not* associated with heat. To remove reflected infrared from a luminescing specimen, it is necessary to hold back infrared from the light source with a blue-green, infrared-absorbing filter. Then any infrared radiation arising from the subject can only be due to emittance or luminescence. It is also necessary to place a visibly opaque infrared filter over the lens to bar the reflected visible light coming from the exciting source.

Spectroscopic techniques, which involve photographic recording as far out in the infrared as 1150 nm, are beyond the scope of this book. Infrared spectrographic procedures are presented by Harrison, *et al* (1949), and Johnson and Mognihan (1958). Information about spectroscopic emulsions on films and plates that can be used in view-type cameras is given in Kodak Publication No. P-315, *KODAK Plates and Films for Scientific Photography*. This data book is available from photo dealers. Infrared astronomical photography is also too specialized to be dealt with here. Key references are Merrill (1934), Herman and Leinbach (1951), and Keene (1967). Tombaugh (1964) discusses investigations within our solar system. Medical and some biological applications are fully covered in Kodak

*This inclusive term will be used to cover emission generally, when the difference between infrared **fluorescence** or **phosphorescence** is not stated. **Fluorescence** is an emission of radiation that persists only as long as the source of excitation remains turned on. **Phosphorescence** refers to emission that continues after the source has been turned off; this term is also used to describe the autogenous glow of certain chemicals and living organisms.

FIGURE 2—Photographs of a hemlock knot, 1/4-inch thick, made to demonstrate the various types of images recorded by infrared photography. **Top left:** Visual appearance; **top center:** infrared reflection; **top right:** visible transmission; **bottom left:** infrared transmission; **bottom center:** infrared emission (luminescence). Two 1/8-inch wood screws, 1/16 and 1/8 inches below the surface, serve to indicate the penetration of infrared radiation into the wood and the translucency of the wood to infrared.

Publication No. N-1, *Medical Infrared Photography,* which can also be purchased from photo dealers.

Infrared research should be distinguished from infrared photography in research. When infrared photography is used in research, the camera is part of the vast instrumentation of today's technology. It may aid in discovering facts through incidental infrared properties, and thus becomes a valuable tool in numerous investigations. On the other hand, infrared research leads to the analysis of infrared phenomena, but often reveals characteristics useful in basic research. Its end is usually classification and explanation, and it generally utilizes specialized photographic equipment or techniques, such as spectroscopy. Sometimes it utilizes completely nonphotographic apparatus. The extensive bibliographies of the Library of Contress (1954 and 1957) should be consulted for numerous references on infrared research.

Books by Hackforth (1960), Holter, *et al* (1962), Wolfe (1965), and Simon (1966) offer good discussions of infrared physics and optics. They cover materials, properties, and instruments, as well as their applications in science and in terrestrial and space technology. Infrared regions of longer wavelengths than those with which we are concerned in infrared photography are dealt with in these books. Extensive books on infrared photography, that cover theory as well as practice, are those by Rawling (1945), Clark (1946), and Wagner (1965). Engel (1968) has edited a valuable book on photography in general for the scientist and has included a chapter on infrared photography.

Infrared Color Photography: Any portion of the spectrum to which photographic materials are sensitive can be recorded in a color film if the individual emulsion layer is correspondingly sensitized. Furthermore, the color of the dye formed in a particular layer need bear no relationship to the color of light to which the layer is sensitive. If the relationship is not complementary, the resulting colors are false. False-color films can be used to emphasize differences between objects that are *visually* quite similar. Color infrared-sensitive films emphasize differences in infrared reflectance. Figure 3 is a simplified diagram that demonstrates graphically how the colors of the terrain are reproduced *falsely* on a color infrared-sensitive film.

All three layers are inherently sensitive to blue radiation. Therefore to limit the exposure of each layer to its intended spectral region, a yellow filter (minus blue), such as a KODAK WRATTEN Filter No. 12, is always used over the camera lens. With the yellow filter in place, the layers act as though they were sensitive only to infrared, green, and red (as all blue radiation is absorbed by the filter). The gray areas in the top portion of the diagram illustrate exposed areas of silver halide in the various layers from each of the spectral bands reflected from the original scene.

With reversal processing as recommended, a cyan-positive dye is formed in the infrared-sensitive layer, a yellow-positive image is formed in the green-sensitive layer, and a magenta-positive image is formed in the red-sensitive layer. Infrared radiation appears as red, which is the result of yellow dye formation in one layer

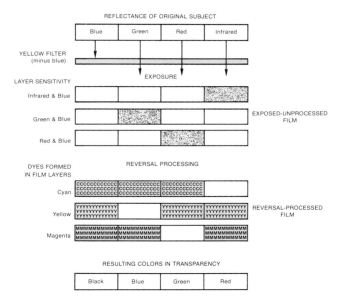

REFLECTANCE OF ORIGINAL SUBJECT			
Blue	Green	Red	Infrared

YELLOW FILTER (minus blue)

EXPOSURE

LAYER SENSITIVITY

Infrared & Blue

Green & Blue — EXPOSED-UNPROCESSED FILM

Red & Blue

DYES FORMED IN FILM LAYERS — REVERSAL PROCESSING

Cyan

Yellow — REVERSAL-PROCESSED FILM

Magenta

RESULTING COLORS IN TRANSPARENCY

Black	Blue	Green	Red

FIGURE 3—Color formation with infrared color film.

and magenta dye formation in a second layer and the absence of cyan dye. Green reproduces as blue—the result of cyan dye formation in one layer, magenta dye formation in a second layer, and the absence of yellow dye. Red reproduces as green—the result of cyan dye formation in one layer, yellow dye formation in a second layer, and the absence of magenta.

Blue in the *original* subject has not been recorded because of the filter and therefore is rendered as black. Numerous other colors will be formed, depending on the proportions of green, red, and infrared reflected or transmitted by the original subject, e.g., green (producing blue) foliage that also reflects infrared (producing red) radiation looks magenta.

Electronic Thermography

Electronic thermography, in a sense, may be considered as an indirect photographic technique. It is the name associated with a group of infrared imaging systems that employ some intermediate means of converting variations in infrared radiation into a visual display that may be photographed by conventional methods. It involves the use of special sensing instruments to record the image of objects whose temperatures may fall well below 250°C and, like thermal photography, it requires no external irradiation. Because it records both reflected and emitted infrared radiation, studies may be done in daylight or darkness; but heat flow studies (object as source) must be carried out in darkness.

Basically, the sensing instrument's optics scan the target point by point. They thus collect infrared radiation emanating from a target and direct it onto a supercooled photodetector. The detector converts this

incoming energy into a proportionate electric signal which is then amplified. This amplified signal may then be recorded on magnetic tape whence it can be manipulated in a variety of ways for interpretive purposes, or it may be used to modulate the input to a cathode-ray tube. The image displayed on the face of the CRT is a temperature profile wherein variations in image brightness correspond to temperature differences in the original subject. This image may be visually observed, and it can be photographed in the conventional manner.

Electronic thermographic instruments have advantages over thermometric devices such as thermocouples, in that they make instantaneous measurements without physical contact, and they give overall readings as opposed to the point readings of thermocouples.

Maresh (1953) describes the use of an electron image-converter tube in infrared photomicrography. Such an instrument is sensitive to the 700 to 1300 nm range and yields records quite similar to regular infrared photographs. It thus operates within the actinic range, but employs some of the techniques of thermal recording. Detailed discussions of thermal recording in aerial photography—usually called "thermal scanning" in this field—are given in Colwell, *et al* (1966), Heller, *et al* (1966), and Colwell (1968).

Medical thermal recording, which is generally called "thermography," may have applications in zoology. The technique is presented in a detailed survey by the New York Academy of Science (Whipple, 1964). Other papers of interest are those by Lawson (1957, 1958), Engle (1961), Barnes (1963), Williams and Cade (1964), and Lawson and Alt (1965). Cade (1964) discusses the use of the "heat camera" in industry. See also "Photography of Hot, Calorific, and Warm Subjects," page 78. Colwell (1968) gives an excellent review of photographic, electronic, and radar aerial recording of terrain and foliage. These references, as well as the discussions in this book, refer to the recording of heat patterns—thermography. This term is also used in other fields to designate thermal photography, in which an image formed by light appears after the application of heat to the sensitive material.

Liquid Crystals

In many applications, high instrumentation cost makes electronic thermography impractical or undesirable. Where this is true, liquid-crystal thermography offers a relatively simple, and much less expensive, means of detecting nonactinic heat patterns.

Some optically active organic materials are capable of forming a phase that is intermediate between the liquid and the solid state. This liquid-crystal phase is

very sensitive to changes in temperature. It manifests its sensitivity, when illuminated with white light, by assuming a color. This color changes as the temperature fluctuates within a thermal range that is specific for each compound. The color results from selected reflection of circularly polarized light, and the wavelength of the reflection band is determined by the molecular structure of the liquid crystal. Above and below the usable temperature range, the substance is colorless. But at the lower end of this range, the material becomes red and progresses through yellows and greens as the temperature rises until, at the upper limit, the color blue predominates. Papers by Woodmansee *et al* (1965) and Strandness (1967) serve as a good introduction to this field.

The progressive reflection of all wavelengths in the visible spectrum can result from a temperature change range as small as 1 Celsius degree in some cases. Thus, very minute temperature differences can be detected. When liquid crystals have been coated on any illuminated object whose temperature profile is within the active range of the crystals, a visible representation of the surface temperature distribution results.

A particular liquid crystal will always show the same color at a given temperature if used alone. However, adding other similar materials to form binary or ternary mixtures can cause certain color changes to occur at particular temperatures. For example, a mixture can be adjusted to cover a range of 30 to 35°C so that the color at 30°C will be red, and at 35°C, blue. The temperature range in which these changes take place is dependent, in part, upon the relative amounts of each component in the mixture.

Color patterns formed by liquid crystals are best observed by reflection rather than by transmission. The surface on which the thermal pattern is to be observed must be blackened before the liquid-crystal solution is applied. A black, washable, water-base paint, brushed or sprayed on, is suitable for this purpose in most cases. This coating must be thoroughly dried before the liquid-crystal solution is added to the surface. The black layer absorbs the light that is not scattered by the crystals, thus enhancing the color saturation.

Permanent records of color thermograms can be made using ordinary color films in any camera that can be adapted to the job requirements. However, when this procedure is being used to measure temperatures accurately, the placement of the lights and camera is an important consideration. The use of strobe flash with polarizing filters over the light source and camera lens is recommended.

Eastman Kodak Company manufactures liquid crystal components and intermediates. Information on these products is available from Laboratory and Specialty Chemical Markets, Eastman Kodak Company.

INFRARED PHOTOGRAPHY OUTDOORS

Outdoor infrared photography is relatively simple because it does not call for the specialized lighting and filtering techniques of indoor work. The outdoor photographer will not need to concern himself with many of the technical details of a comprehensive program of infrared photography. For this reason, outdoor methods are now discussed. Specific details applicable to outdoor photography are given here. Also, pertinent exposure and certain other factors are provided in context; such data can be found by consulting the general index. General aspects of equipment, filters, films, and processing—as they apply to all fields—are to be treated in a section further on in this book.

There are two major fields for outdoor photography. First, there is the work that can be done from the ground. Second, a valuable specialized technique is aerial photography.

GROUND PHOTOGRAPHY

There are two main purposes for infrared photography outdoors. The first is for obtaining technical and scientific information. The second is for providing unusual pictorial effects.

Technical Photography

The success of outdoor photography by infrared lies in the fact that infrared radiation and visible radiation often are reflected and transmitted quite differently by common natural and man-made objects. For example, chlorophyll in live, green foliage and grass absorbs a large percentage of the visible radiation which falls upon it, but transmits most of the infrared. This radiation is reflected by the leaf and blade mesophyllic structure, and therefore is recorded light in tone by means of a black-and-white infrared photograph. (See Figure 4.)

Because of the special properties of infrared color film, healthy foliage records red, whereas verdure under stress photographs in other distinctive colors. Painted materials which match chlorophyll in color, but which have not been treated to reflect strongly in the infrared, will appear dark in an infrared photograph. Some buildings and many types of soil, rocks, and sand also have high infrared reflectivity, which accounts for their lighter appearance or characteristic colors in infrared photographs. Plates I, II, and III, in the center section of this book, illustrate several modified color renditions.

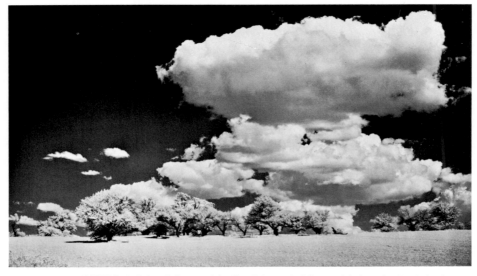

FIGURE 4—An infrared photograph in effect lightens the foliage and darkens the sky of a landscape.

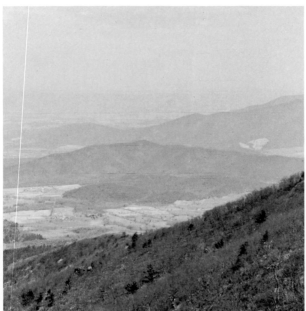 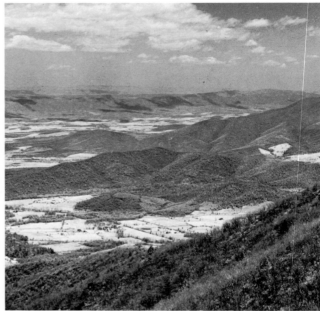

FIGURE 5—A comparison of the infrared rendition on the right with the panchromatic record reveals the ability of infrared photography to "penetrate" haze.

Most photographic materials render blue sky relatively light, but, since little infrared radiation is present in the blue sky, the infrared materials render it dark. This property is often utilized in black-and-white infrared photography to emphasize clouds. (See Figure 4.) The degree of darkening varies with sunlight and haze conditions. Many dyes which appear brightly colored to the eye do not absorb infrared, and therefore, record as white. (This is illustrated in the section on copying.) Infrared color photography depicts blue sky in an almost natural color. The sky reflected specularly from water, or from wet leaves, also records blue. The recorded colors of pigments depend on their reflectance characteristics and are quite unpredictable.

When a distant scene is photographed on the usual photographic material, object detail is often obscured by smoky haze even when a red filter is used. The same objects may be well defined in an infrared photograph for these reasons: (1) the longer-wavelength infrared is scattered somewhat less than is visible red light; (2) the infrared reflectivity and absorption characteristics of natural objects usually enhance the subject contrast; and (3) the ratio of object brightness to atmospheric brightness is usually increased by higher reflectivity of scene details to infrared radiation. The last of these three factors probably contributes the most toward the minimizing of the haze effect. (See Figure 5.) On the other hand, infrared photographs of subjects in a heavy fog are not usually satisfactory because of the large particle size of the water droplets (Mohler, 1936; Clark, 1941; and Wolfe, 1965).

Pictorial Photography

Many dramatic pictorial infrared photographs are obtainable in black-and-white or color; see West (1956), Anon (1966), Gelatt (1967), Weber 1967a,b), and Lanctot (1968). Figure 6 presents an example of travel photography that mainly takes advantage of the haze penetration afforded by black-and-white infrared photography.

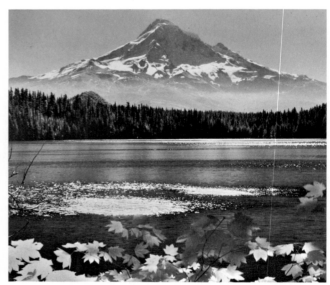

FIGURE 6—Travel records can be enhanced by the inclusion of infrared photographs. Penetration of haze has here delineated Mount Hood, as seen from Lost Lake. Notice that although the trees on the far shore are in shade because of back-lighting, they have not been recorded as a black strip, as would be the case with panchromatic photography.

Infrared landscape photographs in black-and-white are characterized as follows: the sky is depicted almost black; clouds and snow are white; shadows and the shaded side of trees are dark, but usually show more detail than a panchromatic rendition; grass and leaves appear very light as though covered by snow; distant details are rendered with remarkable clarity. Infrared color photography records foliage in a striking red, flowers in modified colors, and some types of stone in quite natural shades—all backed by a pleasing blue sky with white clouds in good contrast.

The exposure required for photography at ground level in bright sunlight, with KODAK High Speed Infrared Film 4143 (ESTAR Thick Base)—sheet film—and a KODAK WRATTEN Filter No. 25, is approximately 1/125 second at f/11 for distant landscapes, and 1/30 second at f/11 for nearby scenes and architecture. The basic exposure for KODAK EKTACHROME Infrared Film is 1/125 second at f/16 with a KODAK WRATTEN Filter No. 12.

Fashion photography with infrared color film produces striking results. Fabrics appear in modified

FIGURE 7—Dramatic impact can often be introduced into architectural photographs by means of infrared photography. The infrared picture at the bottom was made with a KODAK WRATTEN Filter No. 87. The panchromatic comparison shows that even with a No. 15, orange, filter the results are neither as striking nor as three-dimensional.

colors, whereas skin tones, though somewhat "cold," are almost normal. A black hairpiece recorded red in Kaplan's (1967) presentation of several eye-catching examples of fashion illustration.

The photographic illustrator can often dramatize his subjects by making infrared pictures of them. This type of photography gives a good separation of the planes of buildings and darkens the sky to provide a contrasting background. Lightening the tones of trees often avoids "black holes" in the composition. A comparison between panchromatic and infrared rendering of architecture is shown in Figure 7.

Infrared photographs taken outdoors in sunlight and then printed slightly darker than normal strongly suggest that they were taken by moonlight. As a matter of fact, some of the "night" scenes in professional motion pictures are made in sunlight on infrared-sensitive film. Basically, well-exposed negatives are made, and these are printed somewhat dark. Through this means, sunlight appears to be moonlight. The technique does not have the vogue it once had, however, because foliage is rendered somewhat light in tone.

Traveling matte: An application that is not entirely an outdoor one—but not exactly a laboratory technique either, being done on a movie set—has been described by Fielding (1965). It includes a traveling-matte system involving an infrared-negative step-printed to a contrasty record for composite printing. This positive is opaque in the area of the foreground action and clear in the surround. Separation can be effected by placing the actor in front of a black nylon drape which has been dyed with a compound having high infrared reflectance. The traveling matte is effected by illuminating the background with tungsten lamps, which include infrared in their emission. Similar illumination from which infrared has been removed with a dichroic filter is employed for recording the actor on another simultaneously exposed film. A beam-splitting camera is required.

Outdoor Lighting Conditions

For medium-distance photography at ground level and for close-ups of scientific and technical subjects, a flat lighting is usually best. In that way, the shadows obscure the least detail. A hazy light, with scarcely noticeable shadows, is better than full sunlight for revealing a disease pattern on leaves. With full cloud cover, however, it is difficult to predict exposures, but the use of a tripod will probably be necessary. Dark cloud conditions also will affect the color balance obtained in infrared color photography. Since characteristic colors are usually important in this technique, one should take advantage of hazy sunlight or direct

sun. The photographer should stand with his back to the sun, making sure that his own shadow does not fall across the subject.

For plants photographed at 3 feet or closer, the photographer should be particularly careful to find a viewpoint that presents the least amount of obscuring shadows. Flat lighting is usually best; at other times a camera direction at 90 degrees to the sun's rays may disclose the best clarity of un-shadowed detail. Haze may seem to produce a "lifeless" record, but the purpose of the photograph is to reveal information and this is often best accomplished when shadows are completely absent. (See Figure 8.)

It is advisable to introduce a smooth background. Also, a white sheet can be supported behind the camera, between the sun and the subject, to produce the effect of hazy illumination.

Meter readings for ground photography can only be used as a rough guide; the exposures they indicate should be interpreted by experience. Exact speed recommendations are not possible because the ratio of infrared to visible radiation is variable and because photoelectric meters are calibrated only for visible radiation. Use a hand-held meter rather than a through-the-lens type. For critical applications, make trial exposures and determine your own meter calibration. Use the exposure index given in the film data sheet as a starting point.

TABLE I

Approximate, Ground-level, Outdoor Exposures under Varied Conditions; for Kodak High Speed Infrared Film, with the No. 29 filter, and Kodak Ektachrome Infrared Film, with the No. 12 filter

Sky Condition	Suggested Trial Exposure*			
	Black-and-White		Color	
Direct sunlight	1/60	f/16	1/125	f/16
Haze, shadows not quite discernible	1/25	f/16	1/125	f/11
Light cloud cover, location of sun just discernible	1/25	f/11	1/60	f/11†
Moderate rain	1/10	f/8	1/30	f/6.3‡
Heavy thundershower	1/8	f/6.3	1/15	f/5.6‡

*Infrared intensity of the sky varies hourly and seasonally.
†With Kodak Color Compensating Filter CC10M, to offset blueness.
‡With Kodak Color Compensating Filter CC20M.

Table I will serve as a rough guide for Kodak High Speed Infrared Film and Kodak Ektachrome Infrared Film. Of course, it is not likely that infrared photographs will have to be made during rain. Haze, however, does offer a softer lighting than direct sunlight, without shadows. Using a white bed sheet between sun and specimen will diffuse direct sunlight for close-ups, but this method requires an exposure increase of four times for black-and-white infrared photography, or eight times for infrared color photography. (See Plate II.)

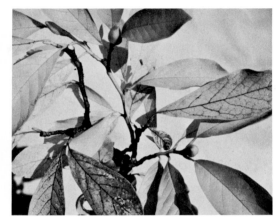

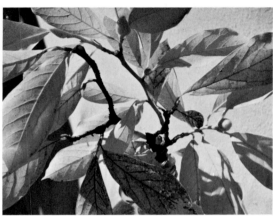

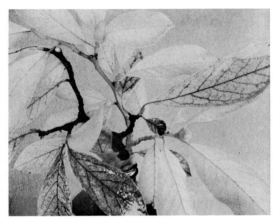

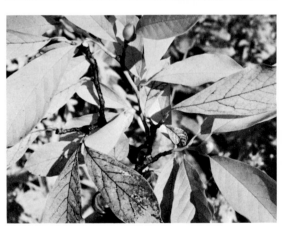

FIGURE 8—Magnolia twigs. The one on the left was infected with a sooty mold resulting from a scale infestation. **Top left:** Panchromatic record; **top right:** infrared rendition made with the sun behind the camera; **center left:** record made with specimens turned 90 degrees to the sun; **center right:** record made with diffuse illumination from complete light-cloud cover; **bottom left:** infrared record made under same conditions as one at top right, except that the khaki blanket that served as a background was removed from the bush over which it was thrown. Notice how diffuse lighting maps the mold distribution by freeing its dark tones from confusing shadows.

AERIAL PHOTOGRAPHY

While infrared aerial photography is primarily useful in enhancing the contrast of the terrain, there are other distinct advantages. For example, bodies of water are rendered very dark in sharp contrast to land, assuming that the day is clear. Fields and wooded areas are rendered very light. Coniferous and deciduous growth is differentiated, the former appearing darker than the latter. Cities are rendered darker than fields. For this reason, in infrared pictures taken at very high altitudes, urban areas appear as dark patches surrounded by lighter countryside. Applications in agriculture, archaeology, ecology, forestry, geology, and hydrology are discussed in this book.

Basic Exposure Data

A high speed black-and-white infrared film, KODAK Infrared AEROGRAPHIC Film 2424 (ESTAR Base) is available especially for use in aerial cameras. This negative material, sensitive to infrared radiation as well as to the blue light of the visible spectrum, has exceptional sensitivity, and is capable of giving high contrast. The diaphragm setting on the camera lens depends on prevailing light conditions, on the degree of development, and to a great extent on the terrain. In this, experience is the best guide. Green countryside requires less exposure than an industrial area.

> On a bright day a common setting based on a solar altitude of 40 degrees and an altitude of 10,000 feet is 1/400 second at f/16 with KODAK Infrared AEROGRAPHIC Film 2424 (ESTAR Base) and the KODAK WRATTEN Gelatin Filter No. 25—red. These typical camera exposures are based on processing to yield an effective aerial film speed of 400.

The KODAK WRATTEN Filter No. 89B—infrared—is also utilized for aerial photography. Its use in place of the No. 25 filter may result in slightly greater reduction of haze effects without an undue increase in exposure.

KODAK Infrared AEROGRAPHIC Film 2424 (ESTAR Base), is available in the 70mm width, in various lengths and wound on various spools. A 3-foot length of 2424 Film can be hand-spooled and utilized in conventional cameras. This provides a means for making preliminary tests to determine the results that may be expected from a full-scale project of infrared aerial photography.* Using KODAK High Speed Infrared Film in 135-size magazines with the same exposure as that recommended for 2424 Film serves the same purpose.

*For aerial photography with conventional cameras, the lens should be set at a focus setting of 50 to 80 feet so that infrared radiation at infinity distance will be recorded in sharp focus. Some lenses provide an infrared focus position, a red dot, to simplify this focus adjustment.

KODAK AEROCHROME Infrared Film 2443 (ESTAR Base) is similar in response to the 135-size film and is used to produce infrared or false-color renditions for aerial applications. Complete information on Kodak aerial films is available in Kodak Publication No. M-29, *Kodak Data For Aerial Photography.*

Sources of Information

Aerial photographic cameras are utilized in extensive survey projects. Flying heights vary from 200 to 80,000 feet. A basic text on aerial photography is the two-volume work edited by Thompson (1966). The Data Book, *Kodak Data for Aerial Photography,* Kodak Publication No. M-29, gives full data on Kodak films, papers, and processing for aerial photography. Kodak Publication No. M-5, *Photography from Lightplanes and Helicopters,* will be found valuable, especially for those who wish to make preliminary trials with a hand-held camera. (See Norman and Fritz, 1965.) The book by Strandberg (1967a) covers the technical aspects of making and interpreting aerial photographs. St. Joseph (1966) and Colwell (1968) illustrate numerous uses of aerial photography.

Modified Black-and-White Technique

A specific phase of aerial infrared photography in sunlight can well be noted here. Spurr (1960) describes a modification of the more common technique. Most infrared aerial photography is done through red (No. 25) or infrared (No. 89B) filters, but certain phases of aerial (and, most likely, ground) photography are better accomplished by making the infrared record through an orange filter (No. 15). Use of the orange filter has been called the "modified black-and-white infrared technique," as opposed to the "true infrared technique."

Spurr states that the shadows of all trees are sometimes so dense in a true infrared record that the excessive contrast of the print makes interpretation difficult. The modified technique results in more luminous shadow detail. Why? While the trees reflect differing amounts of infrared, depending on their species of health, it would seem that an infrared shadow on the ground should be consistent in intensity and thus record to the same density in an infrared negative made by any infrared technique.

The success of the modified technique can be explained on the basis of the green light filtering through the leaves into the shadow—infrared is reflected by the leaves and does not filter through to an appreciable extent. An infrared emulsion is sensitive to ultraviolet, blue, and some green. Red and infrared filters eliminate these spectral regions from the lens image—permitting only some red and infrared (red filter), or

infrared alone (infrared filter), to strike the film. The No. 15 filter, however, passes a small amount of the blue-green light to which the infrared emulsion is sensitive. Hence, a useful proportion of the green luminosity in the tree shadows comes into play in the modified technique. The presence of grass or moss would add to this luminosity.

TECHNICAL APPLICATIONS

The property of differential spectral reflection and penetration of leaves provides many applications for outdoor* photography by infrared reflection. It is interesting to note that Wood, as early as 1910, discovered the light-toned rendition of foliage in infrared photographs of landscapes. Colwell (1968) offers a good review of aerial photographic applications. The benefits are inestimable in botany, agriculture, ecology, tree identification, timber cruising, land management, and plant pathology. These topics will be dealt with separately further on.

Spurr's book (1960) covers many uses of black-and-white infrared photography for tree identification in temperate and tropical forests, as well as many uses in such fields as urban development and camouflage detection. He points out that the energy distribution of atmospheric sunlight peaks at 540 nm, and that the spectral sensitivity of the human eye and the average green reflectance of chlorophyll have similar peaks. The infrared reflectances of various leaves differ, however. From the date published by Gates and Tantraporn (1952), it is easy to appreciate why infrared photography yields a marked differentiation. For example, percentage-reflection figures show 12 green for maple and 4.5 green for many conifers—a contrast difference of 7.5 percent. On the other hand, comparative figures for the infrared are 40 and 18—a contrast difference of 22 percent. Wilson (1960) found that thriving, newly planted, coniferous seedlings could be distinguished from brush by means of the modified black-and-white infrared technique.

Early research was based on outdoor close-up and distant infrared photography on the ground. More recently, extensive aerial photography has been adopted. The value found for infrared color photography has given great impetus to many old and new investigations. Aerial stereo photography in the infrared provides invaluable supplementary information—see White and Hayes (1961); Colwell, et al (1966); Heller, et al (1966); Stellingwerf (1966); and Strandberg (1967a).

*It should be noted that the same properties also permit investigative photography in the laboratory.

Rendition of Foliage

Investigations into the mechanisms of the above mentioned reflection properties have been carried out by several workers. The effect is bound up with the behavior of radiation in or at the epidermis of leaves and non-woody stems; in the pigment cells of chlorophyll, xanthophyll, and carotene; and in the reticulations of the parenchyma.

The epidermis and pigments of leaves are very transparent to infrared. Thus the radiation has free access to the parenchyma. By the same token, the green, yellow, and infrared (but not red) radiations, which are strongly reflected from the mesophyll, readily emerge from the leaf to give it a green color and a bright characteristic in the infrared. Hence, foliage appears light-toned in an infrared photograph.

Inasmuch as a large component of the green is reflected from the surface, while the infrared is reflected and scattered by the deeper tissues, a panchromatic rendition appears sharp, whereas an infrared record is hazy. This and other effects are demonstrated in Figure 9. Note that detail, especially the ridges on the rush, is sharper in the panchromatic than in the infrared photograph.

Other interesting effects of infrared photography are shown in Figure 9, too. Cedar, larch, and hemlock needles have varying visual tones but are more closely alike in a photograph taken by infrared. The wide range of greens and the yellowish-gray lines of the cyclamen leaf disappear in an infrared record. The dark red rose leaf becomes as bright as the light green maple leaf under infrared. The segmental ring of chaff on the rush is bright to the eye but reflects little infrared. The visually bright, chlorophyll-free, white petals of the daisy, as well as its yellow center, reflect no more infrared than the leaves. The white border of the snow-on-the-mountain bract shows the same effect. These facts indicate that infrared is reflected mainly by the tissues of the leaves, that the degree of reflection is not related to the surface color, and that many pigments offer little interference or contribution.

The infrared renditions of foliage in aerial photographs have been studied extensively. Andreucci (1964) came to the conclusion that deciduous trees and conifers could be readily differentiated by black-and-white infrared photography, but that species within each group recorded to about the same tones. Haack (1962) was able to identify hardwood and softwood stands in Alaskan forests. Olson (1964) correlated spectral-reflectance measurements with photographic renditions.

It is with modified color infrared photography that the most informative and striking renditions are

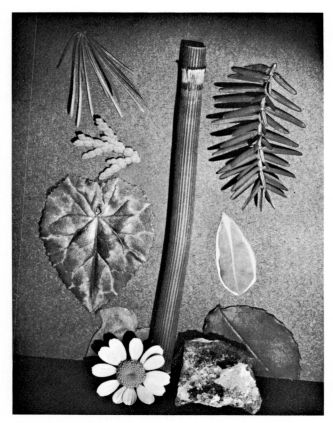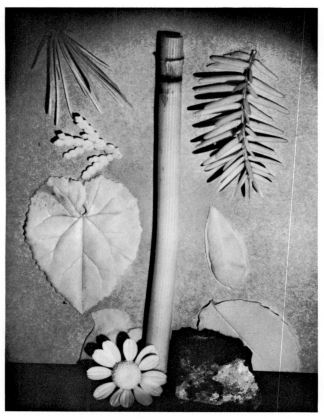

FIGURE 9—Comparison of panchromatic (left) and infrared (right) records, discussed on pages 13 and 14.
 Key: starting with the flower and reading clockwise: Anthemis cotula—Acer platanoides, small leaf from seeding—Cyclamen neopolitan, var.—Thuja occidentalis—Larix decidua—Equisetum hymenale—Tsuga canadensis—Lepadina marginata, bract—Rose, hybrid tea, young red leaflet—Greenockite to serve as a control for luminescence photography.

obtained. Colwell, *et al* (1966), list a variety of colors in which fruit and nut trees are recorded—from pink (peach, almond) through red (pear), to reddish brown (walnut). Other healthy crops yield typical colors—e.g., oats, reddish; safflower, dark pink; alfalfa, red. Stellingwerf (1966) includes a discussion of conifers and reports a predominant bluish purple. A wide range of foliage colors are presented by Fricke and Volger (1965).

Plant Pathology

Many plants under stress from disease or insects can be detected by infrared photography because there is usually a loss of infrared reflectance from affected verdure. For example, Bawden (1933) found that potato streak virus damage appears darker in an infrared photograph than to the eye. His work was done in the laboratory, but it is safe to assume that at least the close approach possible with outdoor photography at ground level could map infected areas.

Colwell (1956) felt that certain grain rusts caused the mesophyll tissues to become impacted and semi-transparent to infrared before there was a visible loss of green coloration. Infrared photography thereby provided early detection and localization. Fungus disease can be similarly located (and hence treated early) in citrus orchards. Oak-roof fungus can be detected in young plum orchards, and the affected trees then replaced with a resistant strain. Gross determinations of sub-surface pH can be made from the photographic appearance of plum foliage in an infrared survey—unsuitable areas can be treated or productivity assessed.

In a more recent paper, Colwell, *et al* (1966), utilized infrared black-and-white and color photography in crop surveys. They further included studies of Phytophthora infestations in navel oranges and potatoes. More accurate information was obtainable from photographs, made from a height of 2 miles, than was obtainable by experts walking through the same areas. These authors presented tone-signature keys for various crops that are valuable aids to photointerpretation. An interesting discovery was that the hypae of powdery mildew brightened the tone of plants in the early stages of attack.

The value of infrared color photography was also demonstrated by Norman and Fritz (1965), in connec-

tion with the problem of surveying the approximately 55 million citrus trees in Florida. (See Plate II.) Trees under stress gradually lose their infrared reflectance. The reddish photographic rendition of healthy trees grades into magenta, purple, and green as the loss of infrared reflectance progresses. Distinctive colors were obtained from the effects upon citrus trees caused by their principal diseases—footrot, advanced nematode infestation, very early tristeza virus reaction, and manifestations of psorosis, xyloporosis, and exocortis viruses that had progressed beyond the mild stage. These authors also discussed filters for obtaining an optimum color balance for recording the fine distinctions in color required. Fritz (1967) should also be consulted.

Heller, *et al* (1966), investigated the photographic detection of bark-beetle damage to ponderosa pine. Like Wilson (1960), they found black-and-white infrared photography ineffectual. With color photography and infrared color photography, however, Heller's group was more successful. Both color methods yielded good results. While the infrared color technique has been found better, especially when haze is present, more skill is needed in interpreting the records. Stellingwerf (1966) discusses instances of detecting forest diseases. Orange spots appear in conifers attacked by the pine beetle and the Douglas fir beetle; sucking insects produce damage that records as whitish spots on silver fir in Oregon. Ciesla, *el al* (1967), state that much time is saved by studying infrared color transparencies, instead of ordinary ones, in aerial photographic location of damage caused by southern pine beetles. The infrared color record sharply delineates the conifers, so only the images of such stands need be searched, instead of the entire photograph. Damaged trees stand out as bright yellow spots; this is illustrated in Plate II with a section from an aerial record. When thousands of trees appear in aerial transparencies, it is important to confine the search to the kinds that could be infected.

Manzer and Cooper (1967) have found the modified color transparency to be extremely informative in the detection of late blight and other potato diseases. Color changes could be recorded before visual symptoms could be seen. They also discuss standardization of technique and the use of a densitometer for quantitative evaluation.

Plant debility as a result of problems with soil and water is taken up in the next sections. The value of photography in all studies of foliage and verdure under stress lies in early and relatively easy detection of disease. Photography can also indicate remedial steps and make their application quick and efficient. These advantages are particularly beneficial when large orchard and agricultural areas or inaccessible forest regions must be studied.

Ecology

Ives (1939) discusses the advantages of infrared ground photography in this field. His observations cover the identification and appraisal of trees and smaller vegetation. Plants flourishing in ideal soils could be distinguished from the same plants growing under submarginal conditions. Useful records could generally be obtained from verdure up to 10 miles from the camera, and sometimes from as far as 50 miles.

Aerial photography has a bearing on many natural-science projects, and some of the applications might be adapted for ground photography in biogeography. Damp areas photograph darker than dry ones, for example. A very complete book in this field is Spurr's (1960). It is likely that studies in the ecology of areas adjacent to cultivation could benefit through indications of moisture conditions in bare ground. Spurr also was able to differentiate plant growth in such areas.

FIGURE 10: Several precautions are necessary to make serial infrared photographs that relate meaningful data. The photographs shown here were taken in early spring (left) and mid-fall (right). The photograph at the left was made under slightly diffuse sunlight at high noon with a No. 87 filter, and the photograph at the right was made about 4:15 p.m. under bright sunlight with a No. 25 filter. Factors that would aid in making this comparison more valuable include: use of the same filter, light conditions as similar as possible that include both the quality of the light and the time of day used, the same camera position, and identical processing of film from one emulsion batch. Of course, since conditions change drastically from spring to fall, several photographs taken during that time span would better show the progress of change.

Myers, *et al* (1963), reported that physiological drought causes a lowering of infrared reflectance. They discussed cotton as an indicator plant for mapping regions of excess soil salinity. Pictures taken three weeks prior to normal harvesting time gave the best indications. They recommended infrared photography (black-and-white) in the early morning, when the plants have the highest turgidity. Colwell (1967) gives a concise description of infrared color renditions in ecological applications.

Hydrology

Natural and polluted water resources have received extensive attention. Hydrological surveys show that even a few inches of clear water photograph very dark on infrared film. Infrared photography has been used to delineate the water lines of tidal country, according to Jones (1957). He suggests using this technique in drainage and other land-development projects. Muddy water shows up in lighter tones than clear expanses. It has been found that brownish, silted water may appear green in an infrared color transparency. Infrared film may be used to clearly delineate patches of floating plants and algae in turbid water areas, especially infrared color film. For topographic mapping by aerial photography, Norton (1964) utilized infrared photography to detect drainage patterns and overgrown shorelines. Stellingwerf (1966) pointed out that small, hidden, jungle streams could be delineated by the slight color differences recorded in the adjacent trees. Colwell (1968) described how muddy water pumped into a mangrove swamp damaged the trees to the extent of causing a dark infrared record.

Strandberg (1964, 1966 and 1967a) has published extensive data on the value of infrared photography in detecting sources and extents of polluted water. He states that many pollution problems arise because the sources are unknown, the consequences not observed soon enough, and the effects not appreciated by those authorities delegated to control such matters. Aerial infrared photography can detect critical areas and reduce field work by guiding technicians in taking laboratory samples. Some of the color renditions Strandberg presents (1966) are a comparison between an efficient sewage-disposal trickling filter (black) and an odoriferous, overloaded one (reddish). On infrared color film, clear water photographs black; water suffused with algae, red; and water with a low dissolved-oxygen level, milky. Infrared color film depicts changes in vegetation growing near outfalls of chemical exotics in a cyan hue, in contrast with the magenta-red of healthy flora (Strandberg, 1964). These changes cannot be seen by the naked eye.

Geology

Other features of terrain besides botanical features can be studied photographically. Lattman (1963) discussed the differences in renditions of shale and limestone. Many rocks appear blue-gray in the modified-color transparency. Locations of springs can be detected from a great height. Cade (1962) also studied features of the earth's surface. He made the observation that the technique was not very effective in desert and polar regions. However, Harwood (1966) found thermal imagery quite informative in aerial photography of the Arctic. Colwell, *et al* (1966) discussed the detection of alluvial drifts. Also, Colwell (1968) treated the differentiation of rock outcrops. White and Hayes (1961) pointed out the value of stereophotography.

Animal Studies

In Cott's comprehensive book on general animal photography (1956) there are pertinent discussions on infrared renditions. In many animals, infrared reflection patterns have no relation to visual appearance. When studying adaptive coloration, Cott found that protection usually did not extend to the infrared aspect. However, using black-and-white infrared film, he found that some caterpillars exhibited infrared reflection effects like those of the leaves which camouflaged them. Even these caterpillars can be differentiated by infrared color photography, according to Gibson, *et al* (1965), who found, too, that imbedded melanin pigmentation in frogs and toads records blue, instead of the red of superficial melanoses. (See Plate III.) Cott's book also has an illustration of a nesting duck securely hidden in a panchromatic record, yet starkly revealed in a black-and-white infrared photograph. This type of photography may have application in wild animal counting.

Colwell, *et al* (1966), devoted a large amount of space to the infrared photography of livestock. By means of the technique, they were even able to sex the cattle and differentiate between Herefords and Hereford-Angus crosses. The counting of pigs, goats, sheep, cattle, and horses can be greatly facilitated by the modified black-and-white infrared technique.

Archeology

Wilson (1960) points out that infrared photography provides some refinements over the panchromatic technique that has proven so valuable in archaeological surveying. Many crop and soil marks and other land scars have not yet disappeared to the infrared camera, even though they are indiscernible to the eye or fail to record on panchromatic film.

An exciting photoarchaeological find is cited by Strandberg (1967b). An ancient, bastioned fortification was discovered in South Dakota by crop markings appearing in an infrared color transparency. The complete nature of this occupied area had been previously unknown. In the infrared color record traces of later Indian settlement are superimposed over the earlier, apparently Scandinavian, remains. Strandberg states that modified color infrared photography is most useful in photoarchaeology. The illustration for Figure 11 was obtained from one of his color records obtained in the study.

Hirsh (1975) describes the use of infrared photography in investigation of the faded and worn painted surfaces of ancient frescoes.

The book by Matthews (1968) can be consulted for further applications of photography in the many phases of archaeology.

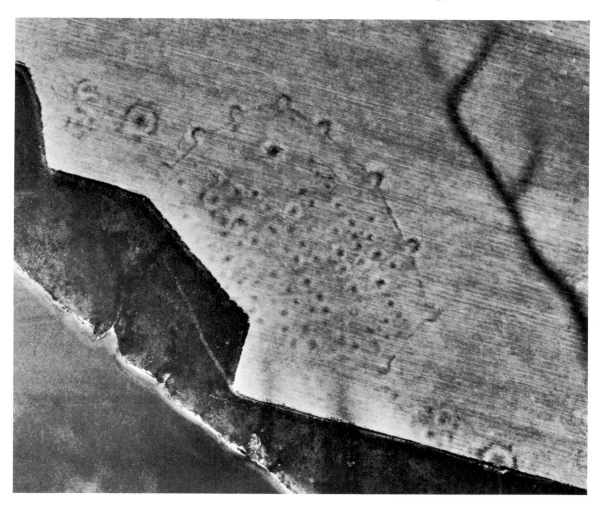

FIGURE 11—Aerial infrared photoarchaeological record made in 1965, of a previously only partially known village site along the Missouri River, 22 miles south of Pierre, South Dakota. The presence of bastions, their 200-foot spacing, and other evidence indicate that the fortifications may have been built by Norse settlers about 1362 A. D. (Reproduced from an infrared color transparency. Courtesy of Carl H. Strandberg, Staff Engineer, Itek Data Analysis Center, Alexandria, Virginia.)

EQUIPMENT AND MATERIALS

No special equipment (apart from filter items to be described) is needed for routine outdoor and indoor infrared photography. It is worthwhile, though, to assess the capabilities of cameras and lights on hand and thus determine their convenience and limitations. The additional equipment needed for some specialized techniques will be discussed as these methods are taken up.

CAMERAS

Any type of view camera regularly used for ordinary photography can be used for infrared photography. Because much of the work, especially indoors, deals with small specimens, the camera should be adaptable for close-up photography.

The most useful 35 mm equipment is a single-lens reflex camera with an automatic diaphragm. It is well suited to handheld operation with infrared color film. Also, when opaque, infrared-transmitting filters are placed over the lights instead of over the lens (as described further on), this camera can also be hand-held for black-and-white infrared photography. But when such filters have to be placed over the lens, a camera with a viewfinder is needed.

If the camera has a through-the-lens exposure meter, the meter should be turned off when an opaque filter is employed. Some work can be done, especially outdoors, with a red filter and with the meter in operation. The camera should be set for the film speed rating without a filter. However, a red filter will affect the spectral response of the meter and may indicate an incorrect exposure for automatic operation. Tests will indicate the need for adjusting film speed.

Checking the Camera

About the only precaution to take with a camera is to be alert to a possible radiation leak through a leather bellows or the camera body, or through a plastic lens board. Should obscure streaks show up on negatives, such a defect is a probable cause. A camera can be checked by placing unexposed film in it and then moving a strong tungsten light around in front of it for about a minute. Any density that occurs on the film is due to an unsafe bellows, lens board, or camera body—provided the shutter and film holder are safe.

To rule out the shutter, cover the lens with a metal cap when you do the test. Then the shutter blades do not become a factor. For sheet-film cameras, load the film into the holder in the dark and insert the holder into the camera in the dark, too. Then remove the dark slide for the test. The dark slide of the holder is thus taken out of consideration.

There is little chance that the blades of most current shutters will cause trouble. However, some older ones were made of hard rubber and some later ones of black plastic. Using them for infrared photography would be like employing blades of almost clear plastic for ordinary photography. A check can be made by focusing the camera on a light bulb. Then, in essence, a film is exposed with the shutter closed. About a minute at $f/8$ should be sufficient time. If no image of the bulb appears on the negative, the photographer can proceed with confidence. Should he have a focal-plane shutter, he should be alert to the possibility that a rubberized fabric curtain may transmit some infrared—evidenced by curtain streaks. The same precaution may be needed with a thin, soft rubber lens cap.

Checking Film Holders

To check a dark slide for leaks, leave it in position over a loaded sheet of infrared film. Then place a large coin upon the outside of the slide and hold the light over the holder for about a minute. If neither streaks nor a shadow image of the coin appear after development of the film, the slide is safe. (Streaks coming in at the edges of the negative would indicate, in the absence of a coin shadow, that the holder may not be safe for panchromatic photography either.) Wooden slides and some hard-rubber slides transmit infrared rays readily and should not be used.*

The speed of High Speed Infrared Film is about 10 times faster than the older film, KODAK Infrared Film. This increased speed at times reveals darkrooms, light locks, camera bellows, or film holders that are not fully opaque to infrared radiation. Although most newer pieces of photographic equipment are opaque to infrared, it is a good idea to recheck both old and new photographic apparatus with the High Speed Infrared Film. The guidelines given above will serve to check equipment for infrared opacity. Working conditions of

*Although several manufacturers of sheet film holders at one time placed five raised indicator dots (instead of a lower number) on dark slides that were opaque to infrared radiation, this practice has lost its significance. Laminated plastic, metal, and most special-composition slides are "safe" for use with infrared-sensitive films.

bright sunlight provide the most stringent test of the equipment and film performance.

Loading 35 mm Film in Total Darkness

KODAK High Speed Infrared Film must be loaded and unloaded in total darkness because the felt-lined slots of the magazines are not "lighttight" to infrared. Since darkroom loading is not required for most other films, this procedure may require a bit of practice to obtain proficiency. An organized workbench alleviates fumbling in the dark. Loading 135 magazines in total darkness requires the same manual activities as does loading film in subdued light; however, feeling the camera take-up spool and sprockets will be the only way to make sure that the film is loaded and threaded properly. After closing the camera back, turn the film rewind mechanism in the rewind direction to put a very slight amount of tension on the engaged film. If the film is loaded properly, advancing the film a frame or two will correspondingly move the rewind mechanism and verify that the film is indeed being advanced. The camera must be returned to total darkness to unload an exposed roll of film.

Roll film removed from a refrigerator or freezer should be allowed sufficient time to reach room temperature before opening the package. Both exposed and unexposed film can be safely stored in the sealed film container. See page 32 for storage information.

Most changing bags are not fully opaque to infrared radiation. When loading and unloading KODAK High Speed Infrared Film in a changing bag, a location with subdued lighting is advisable. It is best, however, to first test the opacity of your changing bag with a sheet of film or a piece of 35 mm film that can be pulled from a magazine in the darkroom and put into a bag. A reliable test should be conducted under work conditions for about twice the amount of time required for loading and unloading film.

Specialized Cameras

Aerial photography has already been discussed and references made to basic information on equipment and techniques. It is beyond the scope of this book to go into detail on aerial cameras.

Studies of the nocturnal behavior of animals are described in the literature cited further on. These studies sometimes call for specialized cameras. For example, motor-driven 35 mm cameras are essential when many rapid-sequence still photographs are to be made. Also, 16 mm stills can be made in motion-picture cameras equipped with time-lapse mechanisms. High-speed motion-picture cameras are also used for slowing up rapid action occurring in the dark. They usually

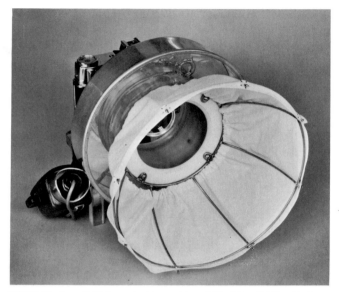

FIGURE 12—Dome light, improvised to provide portable diffuse lighting. The lamp frame is constructed from welded, stainless steel rod. The "lampshade" is white bed sheeting. One or more layers of cloth can be used, depending on thickness of cloth and light intensity needed. The platform for the light and camera is built from 1/2-inch clear plastic material. The dome is supported on a cylinder of the same material, with 1/4-inch walls and an inside diameter of 3-1/2 inches. A metal band holds an electronic flashtube mounted into the cylinder. Seen from the front, the tube is at "2 o'clock." The inner surface of the aluminum "cake pan" reflector is polished.

have to be operated in soundproof booths to avoid disturbing the subjects or to preclude interference with recorded sound.

A specialized setup, improvised for hand-held, closeup, infrared photography is shown in Figure 12. The compact "dome" lighting provides a portable means of diffuse illumination for a wide range of outdoor and indoor subjects. Ambient light, short of direct sunlight, can be ignored.

LENSES

Most good camera lenses serve for infrared photography. Unless a lens has been especially achromatized for infrared photography, however, there will be a difference between the infrared-focus position and the visual-focus position. Usually, this will give rise to no serious problems, yet it ought to be investigated. Some good lenses have a red dot on the focusing scale to indicate an average correction for infrared photography.

In the field of document copying a lens of high quality is advisable, because of the fine detail often involved. And even though such subjects do not present depth-of-field problems, the lens should be stopped down to about $f/11$ in order to offset differences between visible-light and infrared performance.

19

Focusing

In general, if the focusing is done on the near side of the region of interest, no correction need be made. To explain: In focusing it is customary to shift back and forth across the sharp-focus position. This action can be stopped just when the image of the plane focused upon goes slightly out of focus as the motion is *increasing* the lens-film distance toward what would be a nearer visual focus.

Sometimes a specific correction may have to be made. As a general rule, an average correction of 0.25 percent of the focal length should be added to the lens-film extension for infinity focus. For close-up photography at about 1/4 scale, or at greater photomacrographic magnifications, the lens-film distance itself should be increased by this percentage after a sharp visual focus has been made. When a view-type camera can be focused by moving its back, it is relatively easy to measure the bellows draw for visual focus and to move the back away from the lens by the desired amount. When the camera can be focused only by moving the lens, the subject-lens conjugate distance has to be lengthened instead of the lens-film conjugate distance. This is done by moving the entire camera away from the subject by 0.25 percent of the subject-lens distance, or what is equivalent, by the bellows correction divided by the image magnification. The adjustment is made after detail in the area of interest has been sharply focused; this, of course, shifts the plane of visual focus.

In practice, a single-lens-reflex camera should be focused in the normal manner *without* a filter in place. The distance that appears opposite the normal index mark should then be moved to the red index mark (this usually results in a lengthening of the lens). The filter can then be replaced for the exposure. A rangefinder camera can be focused in a similar manner with the filter in place.

Some photographers find an approximate infrared focus with a red filter over the lens, because the pure-red focus of a lens is closer to the infrared focus than the usual blue-green visual focus. However, using the red filter does not guarantee a sharp infrared focus. The filter reduces the image brightness in the finder or ground glass and obliges the photographer to make judgments under conditions of poor visual acuity.

For easier focusing, sharp detail should be sought in the subject. Failing this, black tape, a comb, or some other marker can be placed in the scene to be photographed, as a focusing aid.

The work is seldom so exacting that the methods discussed above are not accurate enough. If necessary, focusing tests can be made. For instance, a steel engraved ruler can be photographed at the full aperture of the lens so as to constrict the depth of field. The ruler should be placed at 45 degrees to the lens axis. An index on the ruler near the center of the field should be focused visually at the subject-lens distance being tested. Then a panchromatic negative should be made. If the selected index is in the sharpest region of the negative image, the focusing scale or film holder is accurate. Without any change in setting or location, an infrared negative is made (in the same holder, when one is used). The shift in focus *along the ruler* is then divided by 1.4 and multiplied by the image magnification. (This last factor is a fraction at scales smaller than 1:1.) The shift will most likely be only about a millimeter further away, and the result of the calculation will yield the lens extension required at the working distance tested.

Sometimes it is difficult to judge whether or not the best definition has been obtained. This can often be ascertained by examining reassuring but incidental detail in the negative instead of the sharpness of the area of major interest, which may not itself have fine structure.

For most subjects the lens will have to be stopped down to at least $f/11$ so that sufficient depth of field will be provided. This procedure also helps to offset differences between the visual and the infrared focus. The specimen should be positioned, and sometimes trimmed, so as to present the minimum depth requirement.

Of course, even when the lens is focused correctly, the infrared image is not as sharp as a panchromatic one. Since lens aberrations have been corrected for panchromatic photography, the anastigmatism is not as perfect in the infrared. Another aspect to consider is subject sharpness. Many biological infrared images are formed from details not on the outside of the subject. Details have a translucent, scattering medium interposed between their outlines and the lens. This accounts for the misty appearance of many infrared reflection records; lateral scattering produces a similar effect in emission photographs. These factors should be borne in mind before one gets too critical of lens performance and manipulative nicety.

The camera is focused in the usual way when infrared color film is used, because the visual component of the image predominates.

Infrared Close-Up Photography

Cameras with nonextendable lenses can be used conveniently for photographing small specimens if the various close-up attachments and supplementary lenses are used. When supplementary lenses are used, it is not necessary to make any compensation in the

exposure for close-up work, since the effective *f*-value remains unchanged. However, for best definition, the lens should be stopped down to *f*/11 or *f*/16.

A handheld, single-lens-reflex camera can be employed for infrared color photography. (Here, no correction need be made for focus.) Such a camera technique can also be adopted when infrared filter material is placed over the lights for black-and-white photography; there is then no need for an opaque filter over the lens. To adjust the focus for a better distribution of the depth of field—especially for close-ups—the field and subject-lens distance are first found by moving the camera back and forth in the usual way. Then, without any change in the focusing scale, the camera is backed off so that the front of the subject is favored. The amount required will depend upon the working distance. Experience will indicate the degree of adjustment to make; it is usually not critical.

Aperture Compensation: When small specimens are photographed, and a considerable camera bellows extension is involved, the effective aperture becomes numerically greater than that marked on the lens. The effective *f*-number for all close-up work can be computed from this formula:

$$\text{Effective } f\text{-number} = \frac{\text{Indicated } f\text{-number} \times \text{lens-to-film distance}}{\text{Focal length}}$$

The lens-to-film distance is the focal length plus the lens extension from its position at infinity focus. This aperture compensation can be readily computed with the close-up exposure dial in the KODAK Professional Photoguide. The plane of the diaphragm is usually a close enough reference point for distance measurements.

With 35 mm cameras whose lenses must be extended for close-ups, the figures in Table II may be used for bellows corrections by measuring the length of the included subject area that will fill the length of the frame. Table II applies to full-frame 35 mm film only.

LIGHTS

Photographic lights of all kinds have high emission in the infrared region of the spectrum. This needs no statement to anyone who has inadvertently come in contact with a hot lamp or taken a flashbulb out of a reflector too soon after it has been fired. It is even possible to feel a surge of heat from an electronic flash unit. Therefore, it is only occasionally necessary to employ other sources. For example, Yajima, *et al* (1962), used 0.2-microsecond spikes of radiation from a ruby laser to photograph the flight of bullets.

In most lighting setups the visible-light intensity does not have to be greater for infrared photography than it does for regular photography. Photographic exposure-meter readings for various setups with photoflood and similar lamps can be directly related. However, the fundamental exposure has to be based on exposure tests in order to obtain negatives of a desired quality.

It is wise to check the evenness of the spot of illumination from any lamp, because variations will be exaggerated by the somewhat contrasty infrared technique. This can be done by photographing the spot of light itself on a sheet of cardboard or on a wall. Also, shadows from indistinct images of filaments or dirty condensers in spotlights should be guarded against.

Tungsten Lamps

It is a mistake to assume that infrared heat lamps are more efficient to use than photographic ones; the converse is true. The infrared lamps are designed for therapeutic use; their radiation is therefore predominantly in the hot-object region of the spectrum. The actinic radiation for infrared photography ranges from 700 to 900 nm. The photoflood lamp is the most efficient incandescent source there is for such radiation. Enough service lamps (ordinary light bulbs) can be used to provide an equivalent infrared exposure, but they will emit much more heat energy than the corresponding photoflood lamps (see Table III). The photoflood lamp is much cooler (for a given exposure

TABLE II

Aperture Compensation for Close ups (for full-frame 35 mm format—24 x 36 mm)							
Length of subject area (mm)*	180	83	50	34	25	19	11
Open the lens by (stops)	½	1	1½	2	2½	3	4
Or multiply the time by	1.4	2	2.8	4	5.7	8	16

*Based on a finder image length of 34.2 mm which is 95 percent of 36 mm full field length.

TABLE III

Characteristics of Incandescent Lamps			
Type of Lamp	Approx. Color Temperature	Average Burning Life (hours)	Ratio of Heat (900 to 2500 nm) to Actinic Infrared (700 to 900 nm)
Photoflood	3400 K	4	1
Service (200 watts)	2850 K	1000	1.6
Heat (without filter)	2500 K	Very Long	12.7

level of infrared) than either of the other lamps, as the table shows. This is an important factor when lamphouses with infrared-filter windows are used or when heat can be harmful to the subject. Balanced against this efficiency is the relatively short burning life of photofloods.

It is practical to use 3200 K photographic lamps in place of photofloods. They are about as efficient as photoflood lamps and have a somewhat longer life. They are available in most photographic departments. Tungsten halogen ("quartz-halogen or iodine") lamps are also suitable for many phases of infrared photography, provided infrared has not been filtered out.

It should be noted that when two photofloods are lit in series, their color temperature is about 2600 K; then they perform and last like infrared heat lamps. It would be convenient to so use them when long lamp life is desired. This may be the case in an animal experiment extending over a period of time and not demanding a high degree of actinic infrared output for a useful exposure time.

If therapeutic lamps are pressed into occasional service for any type of infrared photography, the transmission of their red glass should be checked. Some absorb blue light but transmit part of the green region and the red. Photographic tests of the same subject should be made with and without an infrared filter. The technique would be simplified were the filter not needed, but would be no simpler than that based on unfiltered photographic lamps and a red lens filter. The filter glass over the lamp minimizes the excess visible light of therapeutic heat lamps, but it does not reduce the excess heat.

Photoflash Lamps

It is practical to coat a dark-red, infrared-transmitting envelope over photoflash lamps in manufacture, because they are used only once. Other sources are usually too hot for such treatment. Flashbulbs of this kind are designated "R."

They are valuable when bright visible light has to be withheld from living subjects, as well as from the emulsion. For instance, they may be used for photographing eye responses or the actions of an animal in the dark. The use of the "R" flashbulbs would eliminate the need for special lamphouses with windows covered by large sheets of filter material. The practicality of changing bulbs for each exposure must be considered.

Currently, we know of no U.S. supplier of infrared photoflash lamps. When considering a project that might require these lamps, make inquiries about availability through your professional photographic dealer or consider the alternatives of coating your own lamps or using suitably-filtered electronic flash lamps.

The formula for a "blackout coating" for flashbulbs is published in the *Photo-Lab Index* (Morgan & Morgan). Sources for the required dyes are also given there.

Clear photoflash lamps should be used for routine studio work with animals. The optimum filtering is then done at the lens or over the lamp reflector. (See Figure 13.)

Electronic Flash Lamps

Electronic flash units have many advantages in the photography of living subjects. Their benefits of coolness and short exposure time are extendible to infrared photography. The amount of infrared radiation emitted in electronic flashtube setups is comparable, exposurewise, to the intensities in photoflash setups that would be employed for photographing the same subjects. Another advantage of these units is that they are more readily obtainable with compact reflectors than is tungsten flood equipment. Preferably, they should be equipped with modeling bulbs. Low-voltage lamps have a higher proportion of infrared radiation than the high-voltage units.

Special-Purpose Setups

Pupillography, or any application necessitating photography under low levels of illumination or involving several serial exposures, is best done with lamphouses or lamp reflectors fitted with large sheets of infrared filter or glass. A safelight can be so adapted, but cannot be turned on for long because of the difficulty in ventilating a tungsten lamp of the necessary wattage. For this reason an electronic flash setup is more suitable. Repetitive-flash units (those that can be flashed a number of times a second at full power*) are indispensable for rapid serial photography. Lamp manufacturers can be queried as to specifications.

Lamphouses for Photography in the Dark: It is relatively simple to cut a sheet of gelatin filter to tightly fit over electronic flashtube reflectors. The size of the

*There are accessory units available from lamp manufacturers that provide rapid flashes at partial power, but their purpose is that of enabling the photographer to study his lighting—the photography is done with a single flash at full power.

window can be drawn on a sheet of wrapping paper; then the gelatin filter can be placed between this and another sheet of paper for cutting.

When a lamphouse is constructed to hold tungsten lamps, adequate ventilation must be provided to prevent overheating. The vents must be light locked to minimize stray illumination. A glass infrared filter would be more durable than gelatin filters, but it can crack from heat. Since molded, infrared-transmitting, glass comes in a maximum size of 6-1/2 inches square, it is necessary to construct a lighttight lattice framework for making a window of suitable dimensions.

Provided short or synchronized exposures are given and the lamps are filtered, no infrared filter is needed over the lens when (1) photography is done in the dark or under dim light; (2) photographs are made in the dark of responses to non-stimulating red light; or (3) low-level red illumination only is used for observation.

Fluorescent Tubes: In addition to tungsten lamps, white fluorescent tubes can be utilized in the photography of infrared luminescence. It should be noted that fluorescent lights such as those commonly found in greenhouses do not supply infrared for reflection photography. Luminescence is an emission technique and thus can benefit from the use of cool-burning fluorescent tubes. This will be discussed fully in the section dealing with that technique.

Dome Light: A wide variety of close-ups can be made with a dome light. (See Figure 12.) This type of light was worked out to provide a portable source of diffuse, indirect illumination. It is only practical for close-ups, and is not suitable for illuminating the posterior region of cavities.

The dome light is useful for photographing many small living subjects in the laboratory. Also, it would lend itself to many surveys involving small areas of interest. The arrangement would be handy to use in studying changes during the course of laboratory tests and procedures. The effects of some drugs on animals, as well as similar induced changes, lend themselves to infrared photographic study. This light was used for the mesentery investigation and the caterpillar record shown in Plate III.

The dome light was specially designed for infrared color photography, in which no opaque filter is required over the lens. Thus a reflex viewfinder can be used. To obtain this advantage in black-and-white photography, a red filter can be placed over the lens. When operated on batteries, a dome light would provide a means of photographing a range of botanical and other outdoor subjects. Thus the photographer could be independent of lighting conditions, weather, or time of day.

The dome light permits exposures at f/22 when the power pack indicated in Figure 12 is used with a KODAK WRATTEN Filter No. 12 and KODAK EKTACHROME Infrared Film. For projects based on black-and-white film, an exposure of f/22 with a No. 25 (red) filter and KODAK High Speed Infrared Film is acceptable.

Figure 13 shows an arrangement for occasional close-up infrared photography. This setup features readily available photographic equipment and has proven to be quite valuable for many biological applications demanding portability.

Lamps for Infrared Color Photography

Electronic flash illumination is best for indoor infrared color photography. Photoflash bulbs are not suitable. Photoflood and quartz halogen lamps should only be used when circumstances demand, and then only with special filtering, discussed in the section on filters. It is necessary to employ heat-absorbing glass or a gelatin cyan filter.

It is worthwhile to make every effort to utilize electronic flash illumination in this technique. Not only can simpler filtering be achieved, but also the advantages of coolness and quick exposure times can be gained.

Size of Lights

For photography in the studio or for laboratory work, any type of lamp should have a relatively small diameter; reflector photoflood lamps can often serve. As will be discussed in sections on technique, much infrared lighting is of the "copying" type. That is to say, a lamp is placed on each side of the camera at approximately 45 degrees to the lens axis. It can readily be seen that when the bulb is at a 45-degree angle, the edge regions of large reflectors closer to the camera are at an appreciably smaller angle. Thus, these portions of the reflectors can contribute an undesirable amount of specularity in a reflection technique. The problem is not solved by locating a large reflector at a greater angle—the bulb itself contributes the major part of the illumination, and this must often be directed at about 45 degrees. The solution for photographing small specimens lies in adopting a reflector of 6-inch diameter or less, and a lighting distance of about 2 feet. For most laboratory work, reflectors should be used that are about 8 to 12 inches in diameter. Electronic flash units of the home-portraiture or the accent-lighting type are suitable. For photographing eyes and other small subjects, an electronic flash "eye light" is available.* The tube is enclosed in a compact housing

*Lester A. Dine, Inc., 100 Milbar Blvd., Farmingdale, NY 11735.

FIGURE 13—Left: Large, unmounted gelatin sheets of KODAK WRATTEN Filter No. 87 (up to 13 by 18 inches) can be cut and placed over photoflash or electronic flash lamps for synchronized black-and-white exposures under moderately intense ambient illumination. The illustration shows studio lights so fitted. No filter is needed over the camera lens.

Right: An arrangement for hand-held, infrared close-up photography of living subjects. Two 200-watt-second electronic flash units are utilized and are synchronized with a "Y" cord. An ordinary belt keeps the power packs from swinging on their shoulder straps. A threaded aluminum flange is attached to the reflectors with three Phillips setscrews. A retaining ring screws over this flange in the manner of a fruit jar capper. There is sufficient thread to accommodate glass excitation filters up to 9mm in thickness. The glass discs are cut with a diameter 1/32 inch less than that of the filter seat. A 7/32-inch spacer ring was also made and is used with experimental gelatin filters.

The flashholder brackets are pinned with two screws to prevent twisting. The method of mounting will depend on individual equipment. For infrared photography the lights should be dropped as close to the lens level as possible— here, for infared exposure tests, the quick-release plate was temporarily detached from the position shown and its top reattached, with a slight tilt, at the bottom attachment hole. Dropping and tilting brought the light centers to 1/2 inch above the center of the lens. Special brackets could be improvised by the photographer for a sturdy permanent arrangement.

The lens-subject distance should be such that a range of lighting angles between 40 to 55 degrees is not exceeded.

A synchronized flash exposure in ordinary room light was obtained at *f*/22; KODAK High Speed Infrared Film was used in the camera and Corning CSD-30, 2600, glass infrared filters were placed in the lamps. The lamp-to-subject distance was 27 inches with the power pack set for 1/4 power. Luminescence photography with this setup is discussed on page 75.

having a small window (1-1/4 inches in diameter) to reduce the size of the corneal or scleral reflex.

Spotlights with narrow beams can often be adapted for infrared photography, especially for lighting small specimens in photomacrography. Spotlights are sometimes convenient for luminescence studies, too. It is relatively easy to place infrared-absorbing filters in their beams. Also, the intense illumination they provide minimizes the length of the exposures.

Fiber Optics

Most short fiber optic bundles transmit about half the incident actinic infrared and are useful in some photomacrographic and photomicrographic setups. The intensity arriving at the specimen has to be determined by exposure tests.

Snooperscopes

Separate infrared viewing devices are available. A KODAK Safelight Filter No. 11 used with a tungsten lamp in a lighttight housing will supply infrared radiation for viewing. Once observed, the subject can be photographed at appropriate moments with a prefocused camera and infrared film.

FILTERS

Since infrared emulsions are sensitive to the blue region of the spectrum as well as to part of the red and

to the near infrared region, filters are needed for infrared records. Filter factors are given in Figure 14.

In an emergency, black-and-white photographs can be made with infrared-sensitive materials without a filter, but the rendering will be more like that of a blue-sensitive film. The quality will usually be less satisfactory than that produced by either an orthochromatic or a panchromatic film. Reds, greens, and yellows will be reproduced darker than normal; blues, lighter. Massopust (1936a), however, took advantage of both the sharp image obtained through blue sensitivity and the penetration obtained through infrared sensitivity. He produced many informative photomicrographs.

Infrared color photography calls for particular filtering methods. In some black-and-white and color techniques, absorption filters are needed for the illumination. Camera filters for photographing infrared luminescence are covered in the section on that topic.

Eastman Kodak Company supplies infrared-interference filters for highly specialized techniques, manufactured to customer specifications on special order only. These include filters with thin reflective coatings which are tailored to pass long wavelengths, short wavelengths, or a narrow band of wavelengths in the infrared region. They are described in Kodak Publication No. U-73. For further information, write directly to the Special Products Sales, Eastman Kodak Company, Apparatus Division, Rochester, New York 14650.

Filters for Black-and-White Photography

Several considerations govern the choice of filters. The following KODAK WRATTEN Filters will absorb violet and blue for black-and-white infrared photography: No. 15—orange; No. 25—red; No. 29, No. 70—deep red; and No. 87, No. 88A, No. 87C—infrared, opaque visually. The transmissions of these filters are indicated in Figure 14. The red filters can be used when the camera has to be hand-held or when circumstances, like activity on the part of a live subject, make the adding of an opaque filter after focusing impractical. It ought to be noted again that critical focusing through the red filter is somewhat difficult.

Filter effects in black-and-white outdoor photography are demonstrated in Figure 15. A wide range in the degree of sky darkening and haze penetration is possible through the selection of film and filter.

KODAK WRATTEN Filter No. 89B has been designed for aerial photography. It produces records quite similar to the No. 25 filter. However, it affords additional penetration of haze with only a slight increase in exposure time. For aerial photography, filters should be mounted in glass of optical quality; unmounted gelatin filters are likely to result in poor definition. Eastman Kodak Company manufactures gelatin filters but does not offer a filter-mounting service.

KODAK WRATTEN Filters are available in unmounted 2-, 3-, 4-, and 5-inch gelatin squares. Large unmounted sheets, up to 13 by 18 inches, can be obtained on special order for windows in light boxes or for placing over lamp reflectors. (See Figure 13.) Gelatin filters are particularly useful when techniques are being worked out. Once a procedure has been established, it is practical to obtain glass-mounted filters to fit the lens attachments of the camera. Glass-mounted filters, which carry the same number designation as KODAK WRATTEN Filters, are supplied by the Tiffen Manufacturing Company, 90 Oser Avenue, Hauppauge, NY 11787 and available through most photo dealers.* For information on KODAK WRATTEN Filters, write Scientific Photography Markets, Eastman Kodak Company, Rochester, New York 14650.

For black-and-white infrared photography in some highly specialized applications, sharply selective filtration may be necessary. Experimentation should be carried out when there is reason to expect that using the red or longer-wavelength portion of the infrared spectrum might lead to significant differentiation. Exacting work involving such band separation is beyond the scope of this book.

*In the event that your photo dealer cannot immediately supply glass mounted filters, he should be able to get squares of Kodak gelatin filters readily. If the filter holder is traced on a sheet of stiff notepaper, a circular filter can readily be cut with a scissors to fit the holder. It is usually best to place the gelatin square between a fold of paper to ensure smooth edge-cutting.

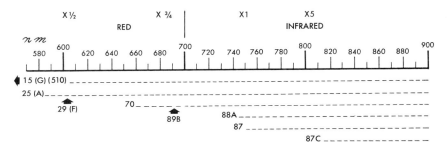

FIGURE 14—Transmission ranges of KODAK WRATTEN Filters for black-and-white infrared photography. Multiplication factors (×) are shown for modifying exposures calculated on the basis of the No. 87 Filter.

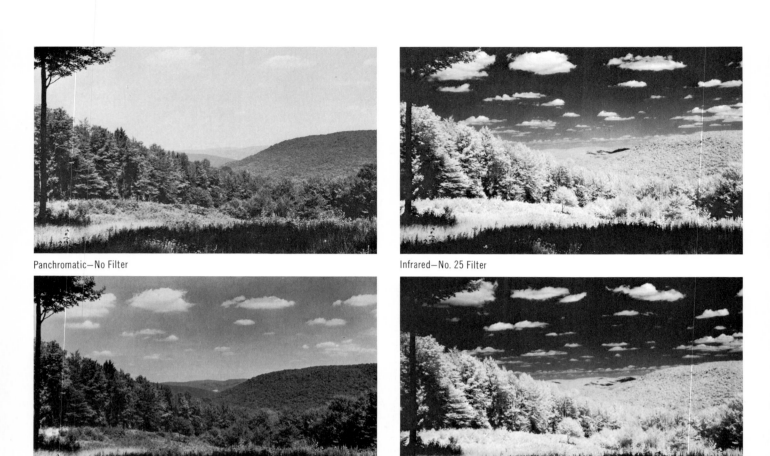

Panchromatic—No Filter

Infrared—No. 25 Filter

Panchromatic—Polarizing Filter

Infrared—No. 87 Filter

Panchromatic—No. 25 Filter and Polarizing Filter

Infrared—No. 87 Filter and Polarizing Filter

FIGURE 15—Successive sky-darkening and haze penetration effects obtainable with filters. Panchromatic renditions are shown on the left; infrared renditions, on the right. The numbers of the KODAK WRATTEN Filters used appear beneath each record. Use of a polarizing filter is also indicated.

For Photography in the Dark: Most individuals can detect a slight red glow through a No. 87 filter with scotopic vision when they happen to be looking directly at the source during an exposure. Bouncing the radiation off a low ceiling, a reflector, or a wall is often helpful, when a subject might see a tell-tale glow as photographs are made in the dark. Alternatively, a No. 87C filter should be considered. The filter coating on the "R" infrared flashbulb cuts just beyond the visible region. Since the cut is not sharp, a glow can be detected. Still, such bulbs do away with the need for an infrared filter over the lens when the scene is in darkness or when ambient or observation illumination is so low as not to affect a synchronized exposure.

Those who wish to construct a lighttight ventilated illumination box with an enclosed tungsten lamp and an infrared-transmitting window for cinematography, should note that the No. 87 filter can withstand two weeks of exposure to a 1000 watt lamp at two feet. The gelatin sheet can be clamped loosely to glass on the lamp side but not sandwiched with another glass, so that it is left free to radiate; a cooling fan can be directed onto it. In our laboratory this filter withstood 5 hours exposure to a 500-watt reflector photoflood at 1 foot. No closer location should be considered and a hot, focused beam must be avoided. The Corning glass color filter, C.S. No. 7-69 (2600), molded, provides a similar filter, but it is a little more sensitive to cracking from heat than the gelatin filter.

Filters for Infrared Color Photography

While KODAK EKTACHROME Infrared Film does not call for the use of an opaque filter for the infrared color photographic technique, a KODAK WRATTEN Filter No. 12—minus blue—should be used over the camera lens. This filter absorbs the violet and blue to which the emulsion is sensitive. The color balance of the film is such that no other filter is normally needed in biological work with illumination of daylight quality.

For outdoor use, a KODAK WRATTEN Filter No. 12 ought to be used, although a No. 8, 15, or 21 filter can be utilized for special effects. However, for scientific photography, where a "biological" color balance is necessary for consistent results, the No. 12 filter *must* be used. (See Plate II.)

For indoor biological photography with KODAK EKTACHROME Infrared Film, it is necessary to use a No. 12 filter along with any other filters to bring photoflood illumination to daylight quality. Since this filtering can be cumbersome, it becomes apparent why the daylight quality of electronic flash illumination is highly desirable for indoor applications. To provide a good color balance for photofloods, a KODAK Color

Compensating Filter CC20C and a Corning glass filter, C.S. No. 1-59 (3966),* are suggested with a filter exposure factor of 2. In some applications, a CC50C-2 filter alone may be used with the No. 12 filter and photoflood illumination.

The unfiltered quartz halogen lamp is useful in the photographic laboratory. It can be utilized for infrared color photography. Since the iodine vapor in these lamps absorbs some infrared, this type of incandescent source does not radiate quite as much excess infrared as that emitted by the photoflood lamp. Accordingly, a heat-absorbing glass filter may not be needed over the lens. Schneider (see page 68) said that a KODAK Color Compensating Filter CC50C sufficed in the light beam of his photomicrographic setup—coupled with the usual KODAK WRATTEN Filter No. 12. For general infrared color photography with the 3200 K and 3400 K lamps, a No. 12 and No. CC50C-2 filter may be used. A filter factor of 2 is required.

The paper by Fritz (1967) should be consulted for other special filtrations in infrared color photography. It offers a guide to individual experiments.

For Color Adjustments: KODAK EKTACHROME Infrared Films are somewhat sensitive to aging. Also, slight differences in emulsion batch, processing, and working conditions are unavoidable. For a given project it may be necessary to trim the balance with KODAK Color Compensating Filters—CC05 or CC10 filters will usually suffice. Table IV provides a guide to making such adjustments.

The KODAK WRATTEN Neutral Density Filter No. 96 (gelatin) is coupled with a silver filter in some color applications. The No. 96 filter is available from photo dealers in a density range of 0.1 to 4.0. Silver density filters can be ordered from photo dealers. They are KODAK Flashed Densities (on film), 4 by 5 or 8 by 10 inches. The density desired should be specified; a range from 0.05 to 4.05 is available. Carbon and silver density filters are used in optical instruments to reduce the illumination when it is too great for infrared color photography. Because silver densities scatter light, they should only be used in an illumination beam—not in an image-forming beam. In a microscope setup (page 68), all the filters should be placed between the lamp and the specimen (except when infrared emission photographs are to be made).

Any filter placed in an intense light beam should be examined periodically for fading from light and heat. When fading happens too frequently, it is necessary to find a cooler, usually broader, location in the beam.

*Specify the filter diameter when ordering Corning glass filters from Corning Glass Works, Corning, New York 14830.

TABLE IV

Filters for Color Balance in Infrared Color Photography			
KODAK Color Compensating Filters*	Desired Color Shift		
Cyan	From green	to	more magenta
Cyan-2	From yellow	to	more blue
Blue	From cyan	to	more red
Magenta	From blue	to	more yellow

Yellow, red, and green color-compensating filters are of no particular value and are not used, except sometimes in photomicrography. Neutral density filters, both silver and carbon, for the light paths of optical instruments absorb infrared selectively and must be calibrated before use; to make the total density required, one of each type should be used. A density ratio of 2:1 (silver:carbon) usually provides a suitable balance.

*A minimum number of filters should be sought in order to avoid degrading the image.

Alternatively, a KODAK Neutral Density Filter (nickel-alloy-coated) can be tried. Its absorption is neutral enough for infrared color photography, and it can be used in either image-forming or illumination beams. The type of filter coated on glass is generally suitable and can be placed in a reasonably hot environment; coated quartz can withstand even more heat. Nickel-alloy coated filters are sold directly by Special Products Sales, Kodak Apparatus Division, Rochester, New York 14650.

For Color Evaluation: In biological applications of infrared color photography, calibrating and checking a given setup should be done by photographing a subject known to yield conformable results. Such a check will sometimes indicate the need for slight filter adjustments. The best "test object" is an area of white, non-suntanned skin of a colleague or assistant. The skin should be recorded as a slightly "cold" white for a good rendition of all biological and medical subjects. If it records too cold, so that veins do not appear in sufficient contrast or reddish areas photograph greenish rather than yellow, a CC10B filter will usually make a suitable correction. When the skin is slightly too yellow in the slide, a Cyan-2 Series Filter (CCO5C-2) will be found helpful. Once a balance has been established for white skin, it can be adopted for any biological subjects, even when skin is not involved. In predominantly botanical applications, a common plant could be used instead as a control.

During the evaluation of the color rendition of the transparencies, KODAK Color Compensating Filters can be placed behind the slides in order to estimate desired changes. For example, if a record is too cyan, placing a CC20R filter behind it might adjust the visual balance. Now, were this an ordinary color transparency, this red filter would be tried over the camera lens for the next tests. Were the printing of a color negative involved, an additional CC10C filtration would be tried in the enlarger illumination. But for infrared color film, reference must be made to Table IV. The above red (CC20R) correction is found in the "more" column, because more red is needed. It will be seen that a blue color-compensating filter at the camera produces more red in the results by reducing the cyan balance. Half the visual adjustment suffices; hence a CC10B filter should be tried.

When a light source, such as tungsten, has slightly too great a proportion of infrared radiation in its balance, or when a fresh batch of film is encountered that has a somewhat high infrared sensitivity, results are yellowish brown. Cyan filters which have some infrared absorption will compensate for this. These are the KODAK Color Compensating Filters, cyan-2 series.

It ought to be noted that strong filtration is usually only required when tungsten illumination has to be used. Such compensation necessitates some exposure increase: for instance, for blue or cyan filters of 50 density, or for a cyan-2 filter of 50 density, plus about 1 stop is needed.

Before entertaining any thoughts on the worthwhile projects made possible by the highly specialized infrared color technique, one must make individual calibrations. The basic principles are simple and well within the knowledge of the competent technical photographer. Once an arrangement has been made, the filter determined, and the exposure calibrated, one great convenience is offered: no visually-opaque filter is needed in any setup. Another advantage is that photographically inexperienced personnel can carry on the routine photography after the procedures have been worked out.

Filters for Polarization

There are conflicting reports in the literature about the effectiveness of photographic polarizing filters in subduing infrared specular reflections. The general conclusion is that the sheets designed for ordinary photography do not polarize infrared radiation. On the other hand, Harris and Latham (1951) obtained a worthwhile improvement when such a filter was utilized, in conjunction with an "infrared filter" (number not stated), to photograph a fossil in a micaceous matrix. Those flakes at the correct angle would present

very strong specular reflections. Any reduction, even if not complete, would result in a much better rendition.

In our biomedical photographic laboratory, leaves were lit at an angle that produced bright specular reflections to the eye. The infrared record, made with a No. 87 filter alone, showed their presence. However, they were not quite as glaring as they appeared visually or as they would have photographed on panchromatic film without a polarizing filter. This was apparently due to the infrared translucence of the leaves, which reduced the relative brightness of the specular component. In this instance, infrared comparison photographs made with a polarizing filter resulted in a scarcely noticeable improvement; the specular reflections were not as bright as those that result from micaceous surfaces. The effect of using a polarizing filter in photographing the blue sky is shown in Figure 15. Polarized exposures are about double that required for unpolarized photographs.

Polaroid Corporation, Cambridge, Massachusetts 02139, supplies a Type HR linear polarizer for near infrared radiation. There may be applications for this special material in photographing glistening specimens or in infrared photomicrography.

Filters for Absorption

Except for the narrowing of the infrared band in some possible application, there is little use for infrared absorption filters in routine technical photography of reflected infrared radiation. However, for experiments with luminescence, infrared must be eliminated from the illumination. Using photographic gelatin filters that absorb red might seem to be the logical way to do this. But none of these filters are satisfactory because all the suitable organic minus-red dyes transmit infrared. Filter recommendations are given in the section dealing with luminescence.

BACKGROUNDS

Painted walls, window shades, and many of the backgrounds ordinarily used in regular photography can be utilized as backgrounds for infrared photography. Some pigments may photograph darker, lighter, or in a different color than their visual appearance, however. This can be checked by making photographic tests. The most reliable light-toned background for large subjects is a tightly stretched white sheet or a white wall, lighted to the same intensity as the subject. Most fairly dark blue and green pigments or dyes found in common cloth sheeting are suitable for yielding dark backgrounds. Green cloth is likely to record as purple in a modified color rendition.

For a negative that is to be enlarged, a material that prints almost black is better than one that is black.

When an enlargement is made, a black background may cause flare, because of the expanse of clear film around the dark image. A dark-gray tone in the print can be achieved by placing the subject a few feet in front of a white background and keeping the illumination on it at a low level.

Light-toned backgrounds are needed when the outline of a subject must be clearly rendered. For example, sometimes the contour as well as the surface detail in a specimen must be depicted. In infrared photography, the dark edge appearing on a rounded subject would merge with a dark background. When only patterns within the confines of a specimen are of importance, sharp edge-separation is not needed. Then a background printing dark gray is recommended, because confusing shadows of the subject will be less prominent.

For a small specimen, a white blotter or the yellow paper of photographic envelopes will provide a good light-toned background. Black photographic separator paper records as a dark gray when lighted to the same degree as the specimen (See Figure 16.).

DARKROOM

All Kodak black-and-white infrared-sensitive films must be loaded in total darkness. Naturally, the darkroom must be lighttight. Also, an electric space heater with exposed heating elements or a cowling that becomes sizzling hot, should not be turned on. Even though the heater may not produce enough visible glow to affect panchromatic films, it could fog infrared emulsions. The temperature associated with steam

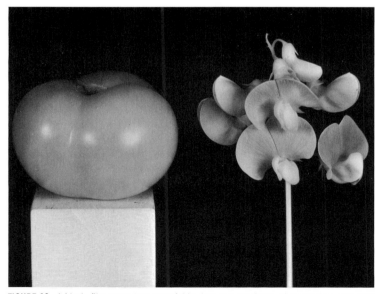

FIGURE 16—A black, film-separator paper, fairly close to a specimen, photographs a very dark gray in an infrared photo; yet the area is not clear on the negative, so flare in enlarging does not become a problem.

pipes and radiators, though, is not high enough to worry about for the handling times required during loading and processing film.

Some wooden doors for interiors may leak infrared radiation through their panels. This can happen when the panels are thin and unpainted. Also, there is a type of door constructed from thin sheets of plywood bonded over a framework. Infrared is very likely to be transmitted through the air cells so formed. If a door is suspected as a source of fog, a photographic test should be made. An attempt to photograph the door is made on infrared film—from inside the darkroom and in the dark, but with full illumination outside. No filter is placed over the lens and an exposure of 30 minutes at $f/5.6$ is used. If no image of panels or air cells appears on the film, the door is safe.

FILMS

The characteristics and availability of Kodak films for infrared photography and general suggestions for using them are given in this section. Since black-and-white negatives can be made from color transparencies, anyone embarking on a color program can publish in color or in black-and-white. This is demonstrated in Figure 11, which was reproduced from color.

For Black-and-White Photography

Specific data on exposures for KODAK High Speed Infrared Films are given in tables on pages 10 and 45 and in the instruction sheets packed with the products. Sensitivity characteristics of black-and-white infrared films are shown in Figure 17.

Film speed for the black-and-white infrared films is high, but the films are normally used with some type of filter. Speed of KODAK High Speed Infrared Films for recommended development in KODAK Developer D-76 is 80 for daylight and 200 for tungsten light. With a KODAK WRATTEN Filter No. 25, 29, 70, or 89B, the speeds are for daylight, 50; for tungsten, 125. Using a No. 87 or 88A Filter the values are daylight, 25; tungsten, 64. With a visually opaque No. 87C Filter, the speeds are daylight, 10; tungsten, 25.

As a general rule, a black-and-white infrared negative should look fairly dense. Grass and trees, particularly, appear much darker than they do in a panchromatic negative. The main features of the subject and areas that photograph dark (light on the negative) should be recorded on the "straight-line" portion of the sensitometric curve. Small black shadows, of course, will have to be blank, because serious overexposure should be avoided. A shadow density of about 0.3 above fog for sheet film, and 0.5 for roll film, yields good separation. Figure 18 demonstrates the quality at which to aim.

These high-speed films have proven to be quite valuable for photographing living subjects with hand-held single-lens reflex cameras or for making records of action in the dark when it is not practical to provide a high level of radiation for the exposures.

Complete information concerning Kodak infrared film products is available in Kodak Publication No. N-17, *KODAK Infrared Films,* or from Scientific Photography Markets, Eastman Kodak Company, Rochester, New York 14650.

For Motion Pictures: KODAK High Speed Infrared Film 2481 (ESTAR Base) is available on special order in 125-foot 16 mm rolls. This sensitive movie film makes

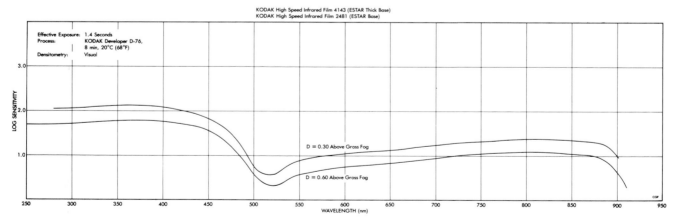

SPECTRAL SENSITIVITY CURVES

*Sensitivity equals the reciprocal of exposure (ergs/cm) required to produce a specified density.

FIGURE 17—The curves above illustrate the typical spectral sensitivity for KODAK High Speed Infrared Film 4143 (ESTAR Thick Base) and KODAK High Speed Infrared Film 2481 (ESTAR Base). Notice that infrared film is sensitive to blue light; this is why a blue-light-absorbing filter is used over the camera lens.

infrared motion-picture photography possible at rather low levels of illumination, or in the dark. Exposure is made with infrared supplied with repetitive-flash electronic flash units or with other lamps, over which infrared filters have been affixed.

With this film, infrared records can be made of operations which must be performed under special lighting conditions, such as photographic processing, materials manufacture, or biological studies under dark-adaptation conditions. The technique is also useful for surreptitious photography, when the subject must not know that he is being photographed—as in criminal or insurance investigations, psychological studies and audience-reaction recording.

For Infrared Color Photography

Infrared color photography, often referred to as modified-color or false-color photography, is accomplished using KODAK EKTACHROME Infrared Film and a KODAK WRATTEN Filter No. 12. This film is ideally suited to photography with hand-held single-lens reflex cameras since it has a speed of ASA 100 and doesn't require the visibly opaque infrared filter used in black-and-white photography.

Table V lists many of the modified color renditions obtainable with the films. These infrared color renditions apply when absorption and reflection alone are involved. They are not necessarily true when color is produced by some other phenomenon, such as light scatter, iridescence, or refraction. Color solely produced by mechanisms other than by light absorption cannot appear the same in an infrared photograph as it did in the original. For instance, an infrared photograph of a spectrum or a rainbow will not reproduce the original colors in the same relative position. The effect can be better appreciated by considering a common subject in scientific photography. A diffraction fringe in a microscope field may visually exhibit a blue, a green, and a red zone. In an infrared color transparency the blue zone disappears, the green zone becomes blue, the red zone becomes green, and an infrared component of the fringe becomes red. Thus the visual blue, green, and red colors are reproduced, but they are displaced one band in the fringe. This effect might have to be taken into account when studying photomicrographs.

A newly purchased batch of KODAK EKTACHROME Infrared Films should be calibrated before it is put in

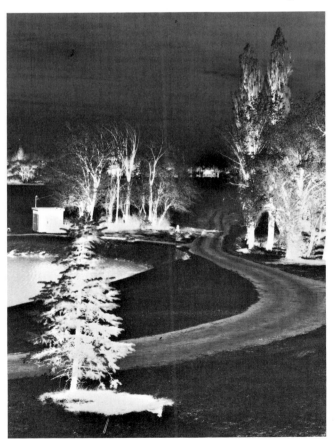

FIGURE 18—Comparison of infrared print and negative to illustrate negative qualities discussed on page 30.

storage, or before it is used in any serial project. The test object adopted should be photographed under the correct illumination, and the results evaluated. The latter procedure is described in the section "For Color Evaluation," page 28. Once the calibration has been made, notations can be made on the box, and the film stored or used. If a batch of film is evaluated and found to yield a red-brown infrared rendition of the subject, it can usually be traced to oversensitivity in the infrared emulsion layer. This oversensitivity of the infrared layer may be corrected in two ways. Cyan-2 filters absorb infrared and can be used to balance the emulsion for a "biological" rendition. The infrared layer may also be suitably lowered in sensitivity by storing or "aging" the film at room temperature for two or three weeks before retesting and moving it to storage in a freezer. This latter method eliminates the need for additional filtering beyond the usual WRATTEN Filter No. 12.

Oversensitivity of EKTACHROME Infrared Film is a rather rare occurrence. On the other hand, loss of sensitivity in the infrared layer due to poor storage conditions is a more serious problem.

TABLE V

Representative Modified Color Renditions

Subject	Color
Botanical	
Healthy-deciduous, green foliage	Red
Diseased or deficient foliage	Greenish, bluish
Badly stressed foliage	Yellow
Conifers	Dark purple
Some blue flowers	Yellow
Red rose	Yellow
Sooty mold on plants	Black
Physiological	
Melanin pigment, superficial	Red-brown
Hemosiderin	Green
Melanophores, in light-scattering layer	Blue-black
Brown hair	Red-brown
Venous blood	Red-brown
Arterial blood	Green-brown
Inflammatory areas	Yellow
Fibrous (collagenous) tissue	Blue
Cholesterol	Pale blue
Tooth cementum	Ivory white
Autoradiographic silver, in tissue	Blue-black
Living or dead unstained bacteria	Reddish
Colored Specimens	
Buff seashell	Orange
Iridescent yellow feather	Blue
Mounted Goliath beetle	Blue
Some green dyes	Magenta
Some green pigments	Purple
Some black cloth	Dark red
Dolomite limestone	Gray-brown
Fluorite crystal	Buff
Khaki background	Orange-red

Latitude

Infrared materials are contrasty; this factor helps to depict faint details in a subject. However, for best results, exposures should be carefully calibrated. In serial studies this is particularly important to obtain validly comparable records. When individual routine black-and-white infrared photographs are made, a latitude of ± 1 stop can be tolerated. However, for survey projects with black-and-white infrared film, and for all work with infrared color film, exposures should be held to within ± 1/2 stop of the best exposure.

Definition

When maximum definition is required for a subject with fine detail, 4 by 5-inch or larger films are preferable to 2-1/4 by 3-1/4-inch sheets or 35 mm rolls. There is a loss in definition when small images are unduly enlarged. Enlargements from sheet negatives made at ×4 show no graininess. Those made at ×6 show noticeable grain, but it is not bothersome, even at reading distance. Miniature films can feasibly be enlarged at ×8 without empty magnification, but a slight graininess will be noticeable. Whenever possible, the film frame should be filled by the area of major interest so that the image is not too small.

Storage

Storage of Kodak infrared-sensitive films in high temperatures or high humidity may produce undesirable changes in the films. To lessen the risk of losing sensitivity and of increasing fog, keep unexposed film in a refrigerator or freezer.

Unexposed KODAK High Speed Infrared Film should be kept at 13°C (55°F), or colder, in the original sealed container. If the film is stored in a refrigerator, remove it 1 hour (1-1/2 hours for sheets) before opening the package or can; if stored in a freezer, remove it about 1-1/2 hours (2 hours for sheets) before opening. Films in long rolls or aerial films will require longer warm-up times (as much as 6 to 8 hours). This will prevent condensation of atmospheric moisture on the cold film. Keep exposed film cool and dry. Process the film as soon as possible after exposure to avoid undesirable changes in the latent image. If it is necessary to hold exposed but unprocessed film for several days (such as over a weekend), it should be refrigerated below 4°C (40°F) and allowed to warm up before processing. For critical uses and for extended periods of time (6 months or more), film in sealed packages should be stored at –18° to –23°C (0° to –10°F).

KODAK EKTACHROME Infrared Film requires more stringent storage conditions than those required for

black-and-white infrared-sensitive films. Adverse storage conditions affect the three emulsion layers of EKTACHROME Infrared Film to differing degrees, thus causing a change in color balance as well as in overall film speed and contrast. A loss of infrared sensitivity and a color balance shift toward cyan typifies film that has been stored in less-than-adequate conditions. This cyan color shift should not be confused with the bluish cast that results from the use of a KODAK WRATTEN Filter No. 8 instead of the No. 12 filter specified for most applications. KODAK EKTACHROME Infrared Film SHOULD BE STORED IN A FREEZER AT –18° TO –23°C (0° TO –10°F) IN THE ORIGINAL SEALED PACKAGE. ALLOW 1-1/2 HOURS FOR FILM (6 TO 8 HOURS FOR AERIAL FILM) TO REACH ROOM TEMPERATURE BEFORE OPENING PACKAGE. Exposed film should be processed immediately following exposure or returned to storage below 4°C (40°F) in the closed film container or package to minimize latent-image changes.

Processed infrared negatives and transparencies should be stored at 10° to 21°C (50° to 70°F) and at a relative humidity of 30 to 50 percent.

Processing

Machine- or hand-development of black-and-white and color infrared film must be done in the dark. Infrared films are carried through the development procedure like any other films. However, it is not advisable to develop a batch of sheet films in a tray by the leaf-over-and-over system. This could easily cause abrasion. Two sheets of infrared film can be developed in a smooth tray by handling them back-to-back. However, they should first be thoroughly wetted in a tray of clean water so that their backings do not stick together in the developer.

Developers and average processing times are shown in the instruction sheets packaged with the films. Development contrast can be varied within certain limits to provide negatives of more, or less, contrast. For records of faint patterns, films can be developed for a 30 percent increase over the average time, if moderate developers are used. The additional fog is negligible and the resultant pattern is strengthened. Consistent development contrast is imperative in making comparable serial records.

Some applications call for negatives of the highest practical contrast; they can be obtained with very active developers. The use of such developers is attended with some increase in graininess and requires a concomitant reduction in exposure. For most biological subjects—especially three-dimensional ones, in which it is usually impossible to eliminate all shadows and modeling—very active developers or increased development are not needed. On the other hand, for some flat-surfaced subjects such as imbedded fossils or faint texts, where surface contours do not introduce lighting contrast, an increased development contrast can be beneficial in strengthening the faint patterns.

Rinsing, fixing, washing, and drying of black-and-white infrared films are carried out in the fashion usual for similar noninfrared materials. No safelighting or infrared inspection equipment can be used during processing. The photographer may have to do his own processing or find a custom processing lab willing to process film under the above conditions.

KODAK EKTACHROME Infrared Film in the 35 mm format is processed in Process E-4 chemicals or Process EA-5 chemicals. Consistent processing is essential for comparable results.

It is important to note that *no safelighting* or infrared inspection equipment can be used in the darkroom during processing. Any custom processing laboratory should be advised of this restriction.

Hypersensitizing: Although it is not practical to hypersensitize KODAK High Speed Infrared Films, the speed of KODAK Spectroscopic Plates and Films can be approximately doubled by hypersensitization immediately before use. Hypersensitizing must be done carefully, or streaked film may result. In drying the film, particular caution must be observed to prevent dust blowing on the emulsion surface; otherwise, spots will occur. A full description of Kodak infrared spectroscopic emulsions and their hypersensitization is contained in *KODAK Plates and Films for Scientific Photography,* Kodak Publication No. P-315 and in *Hypersensitizing of Infrared Emulsions,* Kodak Publication No. P7-670.

NEGATIVE AND PRINT FACTORS

When black-and-white infrared negatives are printed, certain precautions should be taken to assure standardization in the prints, particularly when serial studies are made. In a project of this nature, it is especially important to adopt a standardized lighting for the subjects. Also, consistent exposure and developing techniques for the negatives must be followed.

Standardized negatives are relatively simpler to make than prints. While the negatives are being checked for focus and composition and for the tone quality of the images, they can also be studied from the standpoint of the subject information they contain. The negatives may show up fine differences between specimens that may not be recorded on proof prints. The photographer will then be alerted to the quality needed in the final prints. He may even be able to detect finer differences in the negative than he would be able to distinguish in a good print. Evaluating the quality of negatives and the information they impart should be done on the same illuminator throughout. Stray light should be masked from around the edges of the negatives.

During the printing of infrared negatives the photographer often has difficulty in judging the correct exposure density and contrast, because of the inherent unnaturalness of many of the tones in an infrared rendition. The general tendency is to make the prints too dark and lacking in contrast. If the main purpose of the technique—say, uncovering invisible information—is kept in mind, it is relatively easy to learn to print just dark enough to record the faintest structures or textural detail and just contrasty enough to show them clearly.

When an enlargement is made from an infrared negative of a subject against a black background, or a background that prints deep black, trouble from flare may be encountered with some enlargers. The reason is that the negative bears a very dense image in the center of an almost clear area. The way to minimize the effect is to employ the stray-light masks in the enlarger,

closed to as small an area as possible. Also, the lens must be clean. If the fault persists, a background that prints dark gray should be used in subsequent work to reduce the density range between the subject and the surrounding area.

When serial photographs are made to study variations, such as the changes in a laboratory plant, it is extremely important to use the same grade of paper throughout. Dodging should not be resorted to, since it might introduce artifacts. For many other routine photographs, however, dodging during printing is valuable and can prevent shadowed areas from becoming too dark or can emphasize specific details.

DODGING METHODS

The methods employed in routine print dodging are applicable. Suitably pencilled paper tissues can be placed under the platen in the contact printer. Holes in

FIGURE 19—A fragment of Dead Sea scroll material, presenting white and almost black leather areas, photographed by the infrared-reflection technique. **Left:** Printed from an undodged negative; **right:** printed from a negative dodged during camera exposure. (Specimen photographed courtesy of Abbé J. T. Milik, Pontificio Instituto Biblico, Rome.)

the tissue can be aligned with dark areas in the negative; pencilling on the tissue can be aligned with thin areas. For enlargements, paddles of black paper held on wires and holes in black cards, respectively, permit holding back the exposure from the thin areas and printing-in dark areas with extra exposure.

Dodging during printing, as is well known, requires that image detail exist in both areas. What is not so well known is that dodging can also be done while the negative is being exposed. This expedient reduces the contrast range of the negative. Then, it is easier to record and print all the details.

One worker evolved a dodging technique for photographing Dead Sea scroll fragments. Infrared reflection photography reproduces the writing, even on leather that has become black with age. He employed differential dodging for photographing mixed groupings of fragments. These contained both blackened pieces and relatively unaltered sections—sometimes almost as white as when inscribed. All had to be recorded on the same negative. The light pieces required about 1/3 the exposure needed for the black ones. During the copying procedure, he either held back the illumination from the lighter fragments with paddles, or printed-in black fragments through holes in dodging cards, held in front of one light with the other turned off, depending upon which expedient was more mechanically convenient.

Figure 19 shows how the procedure can be extended even to photographing a single fragment when both white and black areas are present. A paddle was used to hold back illumination from one of the lamps that otherwise would have irradiated the light portion of the fragment. Thus, this portion received 1/2 the exposure of the dark area.

Whenever dodging is employed, the paddles or cards must never encroach on the field-of-view of the camera. If they do, blurred streaks will appear in the photographs.

MASKING METHODS

Masking with a supplementary negative or film positive is a method of dodging that has the advantage of being automatic and also of permitting accentuation of very fine detail. It is especially recommended for records that require the best possible emphasis of details which are faint or indistinct in the subject or for negatives that present an excessive printing range. It is often used in making teaching slides and printed illustrations, in which the maximum of information should appear in a single record.

Area Masks: One masking procedure involves the use of a faint, diffuse, masking positive on film, held in contact with the negative during printing. The dark areas on the mask hold back, and thus lighten, the shadow areas in the negative; this is called an area mask.

When the purpose of masking is mainly to reduce, in effect, the tone range of the negative, a paper of only moderate contrast is selected. On the other hand, when fine details are to be emphasized, a contrasty paper is needed; the mask prevents the general gradation from becoming too harsh; but the paper records the details strongly. The reason is that adding the area mask makes the tones of large areas in the combination of mask and negative more even without essentially affecting the image of fine detail. Because an area mask is diffuse, the fine structures in the negative are prevented from being recorded on the mask as sharp lines. Thus there is nothing in the mask to modify the details. Instead, detail becomes accentuated because (1) the weak positive gradation of the mask cancels out, or flattens, a certain amount of the negative gradation; (2) the paper required for printing the combination is more contrasty than would be needed for printing the negative alone; and (3) the base tones are printed so as to have the general gradation they present on an unmasked print, but the fine lines have a lighter or darker tone, by virtue of the increased paper contrast.

An area mask usually is printed from the original infrared negative in a contact-printing frame, the negative and the masking film being separated by a diffusing medium. KODAK Commercial Film 4127 (ESTAR Thick Base) is a suitable material for the mask. It can be handled under a KODAK Safelight Filter No. 1 (red), which provides good visibility.

The method of introducing the diffusion will vary somewhat with the character of the negative and the tone of the background used. For negatives having a moderate density range between background and subject areas, the most satisfactory diffusing medium is a sheet of flashed opal glass (not pot opal glass). If the negative depicts a subject that has been photographed against a dark background, the opal glass cannot be used. Then, reasonably good results can be obtained with 0.010-inch KODACEL Sheet A-22, matte one side, which can be purchased in local plastics shops. Negatives showing extremely clear background areas and very dark subject areas may not lend themselves to masking at all, because diffusion of light from the background area of the negative into the subject area of the mask will cause light edges on the subject in the final print. Hence, when negatives are to be made especially for masking, a background that photographs dark gray is the safest to use.

For printing the mask, the diffusing medium should be placed between the negative and the film, with the

flashed or matte side in contact with the emulsion side of the negative. A bare, 15-watt, inside-frosted incandescent lamp can be used as a light source. An average printing time is about 10 seconds at 4 feet. The mask should be developed in KODAK Developer D-76 for 2-1/2 minutes at 68° F (20° C) with constant agitation. An efficient acid rinse must be given to stop development immediately.

The suitability of the quality of the mask can best be judged from the results it yields. A mask that is too dense or too contrasty produces a peculiar print quality, somewhat similar to the well-known pseudo bas-relief of pictorial photography. In addition, light edges appear around the subject. When the mask is too light or too flat, not enough improvement over a straight print results.

The quality of an area mask can also be given in concrete terms for those who can use a densitometer in accurately controlling their results. The exposure for printing the mask should be such that the lightest area presents a density of 0.4 to 0.6. The development of the mask should be just enough to give its darkest area a density greater than that of its lightest area by a specific amount. This is usually 25 percent of the density difference of the corresponding areas in the negative.

The completed mask should be taped to the reverse side of the negative. The combination is used in making the final paper print or enlargement. Inasmuch as the mask is a diffuse one, the problem of superimposing it over the negative image is not quite as exacting as it would be if the mask were sharp. Registration scratches made in the corners of the negative will be helpful, though.

Emphasizing Lines: Diffuse area masking is usually done with a positive made from the negative to be printed. Nevertheless, such a mask could also be made from another negative with an image of exactly the same size, but having some difference in image quality—such as that arising from differential filtration. The purpose of the mask made from the auxiliary negative is to subtract certain tones common to both from the main negative. This enables the photographer to print with greater emphasis any fine details that are solely or chiefly recorded in the main negative. When such details exist solely in the main negative, a sharp subtraction mask can be made. When they also appear to some extent in the auxiliary negative, however, they had better be suppressed by diffusing the subtraction mask. Sometimes a diffuse negative mask made from an intermediate positive is effective. The use of such

subtraction masks is discussed under "Paintings," on page 52. For extensive details on the construction of masks, the reader is referred to the paper by Gosling (1962).

Figure 20 records the discovery of infrared luminescence exhibited by the leather of Dead Sea scrolls. Blackened portions emitted infrared almost as strongly as white sections. The 35 mm negative from which the photographs were obtained was greatly overexposed. However, the circumstances under which it was made did not allow carrying out further tests to obtain a negative of the correct exposure, in which the letters would have been recorded more clearly. The print made from the negative exhibited grain encroachment into the script, which caused somewhat diffused characters (Figure 20, at top). This, and the fact that a photograph of any fluorescence is not as sharp as a corresponding reflection record, yielded a mediocre photograph. However, many ancient inscriptions are similarly indistinct, even to reflection photography. Therefore, it was useful to utilize this scroll negative to demonstrate the benefits of masking (Figure 20, in center).

The 35 mm negative was too small to work with conveniently (although this can be done when necessary), so an enlarged facsimile negative was made on 8 x 10-inch film via an intermediate film positive. Next, by contact printing this negative onto KODALITH Ortho Film 2556, Type 3 (ESTAR Base), a sharp but faint positive mask was made (Figure 20, bottom left). Then a diffuse, negative, area mask was made from the positive (Figure 20, bottom right). The two masks were bound together in register with the positive, and a second negative was made for printing the photograph reproduced in Figure 20, center. The sharp positive mask reinforced the density of the script in the positive, but added no density elsewhere. The diffuse, negative area mask reduced the contrast of the background tones in the film positive. It did not introduce density over the central parts of the letter strokes. When the new negative, made from the combination, was printed on a contrasty paper, all but the most blurred letters on the original fragment were well delineated (Figure 20, center).

Figure 19 shows that the dodged infrared reflection technique is adequate for copying scroll material; the luminescence technique was not needed for this particular subject. Of academic interest is the fact that this ancient leather, even when blackened, luminesces in the infrared—a property which is also exhibited by live human skin.

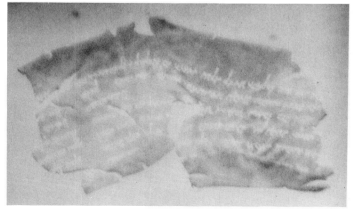

FIGURE 20—Demonstration of masking technique with a diffuse infrared-luminescence record of a Dead Sea scroll fragment. **Top:** Print from original negative; **center:** print from masked copy negative; **bottom left:** appearance of positive highlight mask; **bottom right:** appearance of negative area mask that was combined with the highlight mask and an intermediate positive for printing the copy negative. (Specimen photographed courtesy of Abbé J. T. Milik, Pontificio Instituto Biblico, Rome.)

INDOOR LIGHTING AND EXPOSURES

This section covers the general principles of lighting that apply to the photography of the greater proportion of the subjects likely to be encountered. The more highly specialized lighting setups will be discussed in context with the applications requiring them.

The types of lamps that are suitable for various lighting methods have already been discussed. Regardless of the kind, the arrangement is the same for each kind of lamp, with a given subject. Probably the greatest single factor for success in infrared photography of any type of subject is flat lighting. And, of course, for comparable serial records the lighting must be consistent. A single flash holder at the side of a camera is not suitable, except sometimes for small specimens.

DIRECT LIGHTING

Direct lighting will be described first, because it requires nothing that is not already in the photographic department. In this method of lighting, the lamps are aimed directly at the subject; no reflectors or diffusing media are employed. Special setups for indirect, diffuse lighting will be presented subsequently. One light on each side is sufficient for lighting small subjects. Four lights, two on each side, should be employed for those presenting areas larger than about 20 inches square. When pairs of lights are used in any application, they must all be of the same wattage, and in most instances, must be placed at equal distances from the subject.

In distributing the lighting it is essential to remember that most lights provide a circular pattern of illumination, usually with a central zone of greatest intensity—the "hot spot." Therefore, lights must be far enough away from the subject and be so directed as to spread the illumination evenly and completely over the appropriate area. As a safety measure against the illumination falling off at the edges of the field, it is advisable to spread the zones over an area somewhat larger than the region studied.

Lighting for Copying

The same basic lighting can be used for all flat two-dimensional subjects. These include documents, paintings, flat mineral and fossil surfaces, cloth, wood sections, and flattened leaves. One lamp on either side of the subject-lens axis usually suffices. The diameter of the reflectors should be from 8 to 12 inches. Reflector photofloods are well suited to this application. In order to preclude specular reflections in the direction of the lens, the inside rim of each reflector should be on a line 45 degrees from the surface of the subject. The reason for this is that the reflectors themselves are essentially part of the light source.

Lighting for Specimens

It is vital to avoid, as much as possible, surface shadows from contrasty lighting, edge shadows, and reflections from improper placement of the lights. Thus, there are two requirements for the illumination employed—evenness and the correct lighting angles. The importance of these two factors is illustrated in Figure 21. A large percentage of the faults seen in unsuccessful infrared photographs can be traced to neglect of these principles.

Flat, even lighting calls for an adequate number of lights, an equal amount of illumination on both sides of the camera-subject axis, and proper distribution of the lighting over the subject.

Lighting Angles: The lighting angle is that between the lamp-subject axis and the lens-subject axis. Obtaining correct angles is a matter of positioning the lights. In the horizontal plane (with the subject upright), the lighting angle, which is of course, the same on both sides of the camera, must be just great enough to illuminate the lateral aspects of the subject. It must not be so small as to cause a great deal of diffuse reflection in the camera direction.

The size of the horizontal angle adopted is governed by the shape of the surface being photographed. A convex surface usually necessitates a horizontal angle of about 55 degrees, in contrast to the 45 degree arrangement for copying. On the other hand, a concave surface may require a horizontal angle of only about 40 degrees to preclude the formation of an undesirable shadow at the bottom of the concavity. When lights are aimed in any setup, each lamp ought to be turned on and aimed separately. When the subject is longer than about 20 inches, and four lamps are utilized, vertical angles should be provided by separating the lights vertically. The size of the vertical angle is not as critical as that of the horizontal, and should usually be the

FIGURE 21—A red tomato and a pea inflorescence (Lathyrus latifolius) serve as simple and complex botanical subjects, respectively, for illustrating the lighting of specimens. **a:** Panchromatic photograph made with a 3:1 modeling ratio; **b:** infrared photograph made with a 3:1 ratio; **c:** panchromatic photograph made with a 1:1 ratio; **d:** infrared photograph made with a 1:1 ratio. For **d** the lighting angle was 55 degrees. The lighting angles for **e** and **f** were 30 to 70 degrees.

same above and below the camera-subject axis. However, when a specimen on a bench is being photographed, this is not usually practicable. Then it is often advantageous to place white paper under the specimen in order to reflect fill-in irradiation.

Tungsten illumination presents no problem in aiming the lights. Electronic flash units with modeling bulbs are also readily directed. To obtain suitable lighting directions with flashbulbs, however, it is first necessary to aim the lighting units at the proper angles with tungsten bulbs in place. These bulbs should then be replaced by the flashbulbs for the exposures. The flashbulbs can be fired from an improvised battery box with outlets for lamp plugs.

In Figure 21, the tomato represents a three-dimensional specimen of fairly regular shape. The wild-pea

flowers present a complex subject. The photographs can be made with two electronic flash lamps having 8-inch reflectors. The flashtubes are powered with 225 watt-seconds (Joules) each, and the tube-subject distance is 6 feet with a KODAK WRATTEN Filter No. 87 placed over the lens and a yellow paper background located 6 inches behind the subject.

The lens aperture would be f/32 for KODAK High Speed Infrared Film 4143 (ESTAR Thick Base) and for KODAK PLUS-X Pan Professional Film 4147 (ESTAR Thick Base).

The first three components of Figure 21 were made to demonstrate the need for evenly balanced lighting. Notice that the amount of modeling suitable for panchromatic photography is too much for infrared.

Experiments with lighting angles are shown in the second group of photographs in Figure 21. The angle was varied from 30 degrees to 70 degrees. The most suitable angle was 55 degrees for the tomato. It will be noted that adopting a smaller angle, in effect, darkens the outlines of the fruit and produces a more brightly lit central zone. The difference is somewhat unilateral here because the pea blossom is also part of the field, so that the right-hand light was further from the tomato. However, the effect can be appreciated by comparing the left-hand edge of the tomato record with its center portion—both sides of the fruit would have appeared alike had it alone been the subject and thus could have been lighted equidistantly.

As the lighting angle is widened, the periphery becomes increasingly brighter with respect to the center; the edge is relatively too bright in the 70-degree record. Had there been a recordable disease pattern on the tomato, it would have been clearly and completely delineated in the 55-degree photograph. In the other photographs though, there would have been suppression in the brighter and darker regions—especially if the negative were printed on a more contrasty paper to emphasize the pattern.

As a rough working rule, it can be taken that flat curves and plane surfaces will call for 45 degrees. More acutely curved surfaces will require 55 degrees; and concave surfaces, 30 to 40 degrees. Lighting requirements for regularly shaped subjects are not so rigid as to be difficult to meet.

In contrast, a complex shape, like the pea inflorescence, responds better to the 30-degree angle. The petals present a stronger texture pattern when greater angles are employed and shadows arise that obscure some of the structures. The lighting angle for a subject like this will be dictated by the details under study and by the way in which they can be presented to the camera. Sometimes two records will have to be made. Employing indirect lighting is usually best.

Lighting the Eye: In infrared photography of the strongly curved anterior segment of animal eyes, a single light usually should be located at the camera level and the lighting angle adjusted to position the highlight so that it does not obscure visualization of the iris or other areas of interest. It may be necessary to distract the animal to adjust its glance to suit the circumstances.

The catchlight reflex will appear on the same side as the lamp. Its position will be roughly at an angle—between the camera axis, and a radial line from its own location to the center of curvature of the eyeball—that is half the angle between the bulb direction and the camera axis. Thus a horizontal lighting angle of 90 degrees locates the reflex at about halfway between the pupil and the corner of the eye. A lighting angle as great as this is seldom needed, of course. Varying the vertical lighting angle also helps to similarly change the position of the reflex.

For the surface of an eye, the open-flash technique—with a small bare photoflash bulb—is quite convenient. With electronic flash equipment, a small reflector should be used to reduce the size of the reflex.

At a scale of 1:1, with an electronic flash unit of 30 watt-seconds 18 cm (7 inches) from the eye, try a lens aperture of f/22 for KODAK High Speed Infrared Film with a KODAK WRATTEN Filter No. 87C.

Lighting Small Specimens: The use of a bare, synchronized photoflash bulb is not only practical for photographing animal eyes, but is also excellent for small living subjects in general. A handheld, miniature reflex camera with an automatic diaphragm is most convenient to use. The flashholder can be fitted with a blackened reflector replacing the shiny one, in order to give the effect of a bare bulb and yet shield the flash from the photographer. Electronic flash lamps of small size are also suitable. When two lamps are not practical, a reflecting surface placed opposite the lamp or flashbulb provides beneficial fill-in irradiation. A white card, or the shiny protective wrapper from Kodak sheet films, serves as a handy bounce reflector.

When a camera is hand-held in this fashion, a red filter is needed over the lens, so that focusing and viewfinding can be done. Since a more intense infrared effect is obtained with an infrared filter, a good expedient is to fit the lamp reflector with a piece of such filter material. Then it is possible to see through the lens directly, and any ambient lighting (barring direct sunlight) should not affect the exposure.

Placing filters over studio electronic flash lamps is also helpful for black-and-white photography of living subjects in the laboratory. (See Figure 13.) This is true even when a view camera is used on a tripod; there is no

PLATE I

Top: Color and modified color photographs, made to compare renditions. The piece of camouflage material at the lower left had not been treated to reflect infrared, as the helmet cover had been. Note the differences in the colors of the fruits. The value of infrared color photography in medicine is demonstrated also.
Bottom: The various colors of fall foliage have been strikingly modified by the infrared-sensitive color film. These color translations provide a clue to some of the colors seen in pathological studies.

41

PLATE II

Left, top: Magnolia twigs, one covered with sooty mold (see Figure 8), photographed in sunlight diffused by a white sheet. A green blanket served as a background. **Left, center:** Fluorescence excited by ultraviolet and blue and photographed on infrared color film; renditions are discussed on page 77. **Left, bottom:** Comparison photographs made to demonstrate the variance of infrared renditions of trees. Many plants differ slightly in their infrared reflection. By using the shape of tree crowns and the shape of other plants with their typical infrared rendition, photo interpreters are able to identify different forms of vegetation and appraise their health. **Center:** Plot of trees photographed on infrared color film with a KODAK WRATTEN Filter No. 8 **(top),** No. 12 **(middle, left),** No. 15 **(middle, right),** and No. 21 **(bottom).** In most all cases, the No. 12 filter provides the best color distinctions in foliage studies. **Right, top:** The yellow spots indicate trees under stress from the southern pine beetle. (Courtesy of W. M. Ciesla, United States Forestry Service, Southeastern Area, Division of Forest Pest Control.) **Right, bottom:** Part of a citrus orchard replanted because of nematode infestation. The old trees had been removed and the soil treated. The slightly purple trees around the new plot show, however, that a sufficient number of trees had not been taken out. The tree that has recorded blue was invaded by Phytophthora fungus. (Courtesy of G. G. Norman, Florida Department of Agriculture, Division of Plant Industry.)

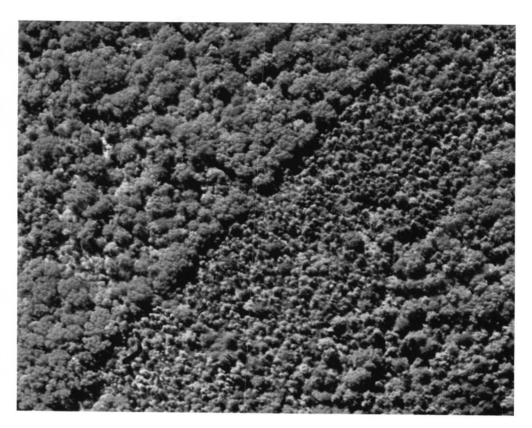

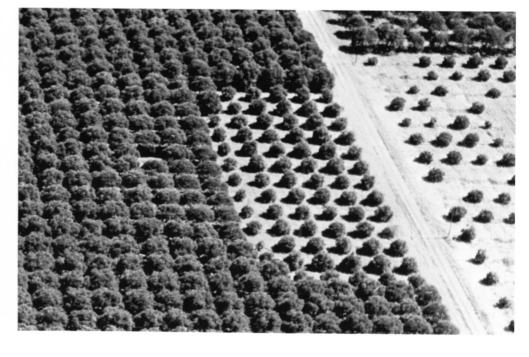

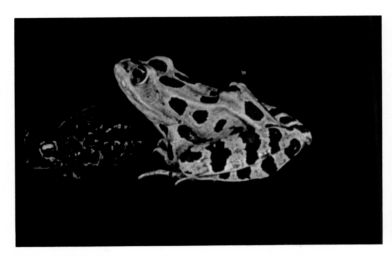

PLATE III

Top left: Frog, Rana pipiens, and toad, Bufo boreas exsul, photographed to demonstrate the infrared color rendition of melanophore aggregations embedded in a scattering layer.
Top right: Caterpillars, Protoparce sp., photographed on a green leaf. Visually, they had the same color as the leaf.
Center left: Rose leaflet infected with black-spot fungus. The area that has recorded yellow could not be distinguished visually. **Center right:** Photomicrograph of a skin section of a patient with localized argyria. The infrared color photograph separated silver sulphite particles (black) from melanin granules (red). No other form of inspection made this distinction. **Bottom:** Mesentery of a guinea pig photographed in a nitrogen atmosphere to show the infrared color renditions of venous blood (left-hand pool) and arterial blood (right-hand pool).

44

TABLE VI

Photoflood Exposure Data
with No. 25 Filter. For 2 R2 Photofloods,
or 2 No. 2 Photofloods in 12-Inch Reflectors.

Lamp-to-Subject Distance (in feet)	3	4½	6½
KODAK High Speed Infrared Film 4143, KODAK High Speed Infrared Film and KODAK High Speed Infrared Film 2481 Lens opening at 1/30 second:	f/11	f/8	f/5.6

All of these settings should be regarded as for trial exposures only.

TABLE VII

Flashbulb Guide Numbers with a KODAK WRATTEN Filter No. 25, No. 29, No. 70, or No. 89B

KODAK High Speed Infrared Film 4143 (ESTAR Thick Base) and KODAK High Speed Infrared Film 2481 (ESTAR Base)

Between-Lens Shutter Speed	Synchronization	AG-1*		M-2†		M-3† 5‡ 25‡		11§ 40§		2§ 22§		Focal Plane Shutter Speed	6‡ 26‡	
		Feet	Metres	Feet	Metres	Feet	Metres	Feet	Metres	Feet	Metres		Feet	Metres
Open, 1/30	X or F	180	55	180	55	280	85					1/30	280	85
1/30	M	120	36	NR		240	70	240	70	320	95	1/60	180	55
1/60	M	120	36	NR		240	70	220	65	300	90	1/125	130	40
1/125	M	100	30	NR		200	60	200	60	260	80	1/125	90	27
1/250	M	80	24	NR		160	50	150	46	200	60	1/500	65	20
1/500	M	65	20	NR		120	36	NR		NR		1/1000	45	14

Bowl-shaped polished reflectors: *2-inch; †3-inch; ‡4- to 5-inch; §6- to 7-inch.
If shallow cylindrical reflectors are used, divide the guide numbers by 2.
For intermediate-shaped reflectors, divide the numbers by 1.4.
NR = Not Recommended.

Caution: Bulbs may shatter when flashed. Use a flashguard over the reflector. Do not flash bulbs in explosive atmosphere.

TABLE VIII

Electronic Flash Exposure Data
with No. 87, or No. 12, Filter. For 2 225 Watt-sec. Tubes in 11-Inch Parabolic
Reflectors, Zones Overlapped, or 4 Tubes in 8-Inch Bowl Reflectors,
Zones not Overlapped. Lens Aperture f/22.

Film	Lamp Distance (feet)
KODAK High Speed Infrared Film 4143 (ESTAR Thick Base)	11
KODAK High Speed Infrared Film 2481 (ESTAR Base)	11
KODAK EKTACHROME Infrared Film	15

Electronic Flash Guide Numbers

KODAK High Speed Infrared Films with a KODAK WRATTEN Filter No. 87										
Output of Unit (BCPS or ECPS)	350	500	700	1000	1400	2000	2800	4000	5600	8000
Guide Number for Distances in Feet	20	24	30	35	40	50	60	70	85	100
Guide Number for Distances in Metres	6	7	9	11	12	15	18	21	26	30

KODAK EKTACHROME Infrared Film with a KODAK WRATTEN FILTER No. 12					
Output of Unit (BCPS or ECPS)	350	1000	2000	4000	8000
Guide Number for Distances in Feet	40	70	100	140	200
Guide Numbers for Distances in Metres	12	21	30	43	61

delay after focusing while a filter is being placed over the lens. Thus an animal is less likely to move out of focus before the exposure can be made.

Basic Exposure Data

Tables VI, VII, and VIII provide black-and-white exposure guides for direct lighting in many general copying and specimen setups. Data are given for the KODAK WRATTEN Filter No. 25—red; filter factors for other filters appear in Figure 14, page 26. No filter is required with the No. 5R photoflash bulb.

For Photofloods: Table VI is based on the use of two No. R2, reflector-type photofloods, or two No. 2 photofloods in 12-inch reflectors, at the distances shown.

For Photoflash Lamps: The guide numbers in Table

VII are given for indoor photography (at least one stop more exposure is needed outdoors). They should be divided by the lamp-to-subject distance, taken to a point midway between the nearest and farthest details of interest. This division will yield the *f*-numbers required.

For Electronic Flash Units: Table VIII will serve as a guide to electronic-flash exposures for black-and-white and color infrared photography.

DIFFUSE LIGHTING

For irradiating complex shapes, or even for obtaining simple and consistent illumination for regular specimens, indirect, diffuse lighting by means of a tent or cubicle is strongly recommended.

Figure 22 compares the results of photographing a regular and a complex specimen under direct and indirect lighting. The cubicle is particularly useful for providing diffuse, even lighting for all kinds of infrared color photography. It is also advantageous for many black-and-white programs, especially when animals are photographed.

The lighting is so diffuse that a restless subject is suitably illuminated in spite of any minor changes in position that it may make. It should be noted that the dome light, described on page 19, provides diffuse lighting. It is intended for photographing very small animals and a variety of small subjects.

Gibson (1964) and Gibson, *et al* (1965), describe a cubicle system developed for the infrared photography of patients. The same system can be adapted to photograph a wide range of biological specimens, museum artifacts, shiny apparatus, and similar complex subjects (Gibson, 1966). The diagram in Figure 23 depicts a suggested arrangement.

The cubicle has a big advantage that is a result of the lighting being so diffuse. A technician can remain inside to perform manipulations during photography. In order to have room and to disturb the light distribution the least, the assistant should stand back of the subject as much as possible, and behind a background card placed on the table.

Cubicle Illumination

To illuminate this cubicle for infrared photography, a pair of electronic flash lamps (225 watt-second) is needed. They should be located outside the cubicle, each at 45 degrees to the lens axis for large subjects, or

FIGURE 22—Simple and complex botanical specimens (green pepper and pea) photographed to compare types of illumination. **Left:** Made with direct lighting from two reflector photofloods; **right:** made in the white cubicle shown in Figure 23.

at 35 degrees for close-ups. The lamps are positioned at camera height above the floor, and 5 feet from the subject. The lamps should not be placed closer to the sheets than 1 foot, or some unevenness in the illumination will result. It should be noted that it is practical to place infrared gelatin filters over electronic flash lamps for black-and-white photography. (See Figure 13.)

In the setup described above, with a No. 87 or a No. 12 filter, a lens aperture of f/22 can be utilized for high-speed black-and-white infrared films and for infrared color film.

Two reflector photofloods could be used to light inanimate objects inside the cubicle. However, the bulbs should be at least 18 inches from the sheeting to prevent scorching it.

A typical exposure is 1/10 second at f/22 with KODAK High Speed Infrared Films and a No. 87 filter, when the lamp-to-subject distance is 3½ feet.

Cubicle Construction

The diffuse lighting system shown in Figure 23 is set up as follows: Two sections of flame-proofed, white bed sheets, about 3 to 4 feet high, are hung on a curtain rail having a 1-1/2-foot radius in front. This forms a curved enclosure, open at the back. The pieces are jointed by a two-way zipper that closes downward and upwards, thus providing a camera slit of adjustable height. A 5 by 5-inch cardboard box, with a 3-1/2-inch circular hole cut in the bottom, serves to hold the zipper runners apart and also provides a camera port. A 6-inch strip of sewing tape at top and bottom extends from the zipper to join the sheets securely. The sheets are hooked at 4-inch intervals. The specimen is placed on a small stand inside the cubicle formed by the sheets. Background material is attached to the wall.

A canopy cut from bed sheeting is hung over the top of the cubicle. The canopy is made removable for laundering by inserting grommets that can be hooked over 1/8-inch machine screws threaded vertically downwards into the top of the rail. A white blotter can be used to cover the bench or tabletop. Blotter and canopy provide diffuse reflections from above and below. The evenness of the resulting illumination is outstanding and well suited to both black-and-white and color infrared photography.

The curtain rail can be extended to the wall to one side of the cubicle. In this way the sheets could be run aside for storage. They could also be pulled away quickly so that comparison photographs can be made under direct lighting with the same lights and without having to move the subject.

FIGURE 23—Diagram of white cubicle for providing diffuse, "tent," lighting for infrared photography.

TRANSMISSION LIGHTING

Thin sections of various types can be examined by the differential amount of infrared transmitted by them. The basic setup comprises an enclosure for the light and a masked window, or opening in a partition, over which the specimen is placed. Details are given in connection with typical subjects discussed below.

Wood Sections

The thin piece of wood (1/4 inch) shown in Figure 2 was photographed in this way. A 300-watt reflector photoflood bulb was placed into a ventilated but light-tight box. Opal glass in the top provided a window and a support for the specimen. The lamp was 6 inches below the glass. An opening just smaller than the specimen was cut in black film-separator paper to mask off stray light. The paper did transmit some infrared radiation but not enough to cause flare. Exposure had to be found by trial because there was not enough visual light transmission through the wood to activate the exposure meter needle. Focusing was done by reflected light in order to prevent overheating.

For hemlock wood, 1/4 inch thick, suitable infrared negatives can be produced on KODAK High Speed Infrared Film 4143 with an exposure of 1 second at f/22.

Mineral Sections

Rhoads and Stanley (1966) describe a setup for the black-and-white and color infrared photography of sections taken from sedimentary cores. They state that suitability of the thickness of a section is first judged by placing it in front of an ordinary 100-watt service lamp—if a small amount of visible light can be seen through the specimen, it is sufficiently thin to be photographed under infrared. They illustrate a light box containing two 100-watt lamps. The specimens are placed on a large sheet of glass in the top of the box. Of course, stray light around the sections is masked off. Photography is done in a darkened room.

Petri Dishes

An early worker with agar plates utilized bulbs in two small reflectors at 45-degree angles to provide direct illumination rather than transmission. However, it is possible that certain visibly dense culture media may transmit infrared rays more freely than the growths on them. A transillumination setup for petri dishes ought to be investigated when other methods prove unsatisfactory. It is likely that thick cultures will respond best, yet the same may be true for precipitation plates, especially if luminescent materials, like chlorophyll, or opaque substances can be feasibly introduced into the media. Nonprecipitating reactions might displace such inclusions to make infrared detection possible. General methods for photographing such subjects will be found in Nace and Alley (1961), Reed (1960), and also in Glazier and Fernelius (1967).

Paintings

Paintings can be photographed with transmitted infrared by transilluminating them. Should the work be done routinely, a large lighttight box or tunnel can be utilized. In the back of the tunnel there should be an adjustable opening large enough to present the area to be examined. The front of the box should have a hinged door and a support for the camera. When the latter has been focused, the door is closed. The shutter can be operated by means of a long cable release extending through a small hole in the tunnel. When only an occasional painting is checked in this fashion, it might not be worthwhile to rig a tunnel. It would be practical to place the camera in one room and the lamp in the next, with the painting supported in the doorway between. Opaque curtains would serve to minimize the amount of illumination spilling over into the room having the camera. The painting could be transirradiated through the back of the canvas. A 500-watt reflector photoflood, 6 feet from the picture, would serve. An electric fan should be used to keep the picture cool, because it is vital not to overheat the painting. Whenever there is the least possible danger of this, a method based on a flash technique must be worked out. This would be especially necessary were the painting lined by means of a wax adhesive.

For KODAK High Speed Infrared Films an exposure of 15 seconds at f/5.6 can be tried, but correct exposure will vary with the subject.

A Kodak worker made several flash experiments with a KODAK WRATTEN Filter No. 87, to determine the exposure level for oil paintings on canvas. His data serves as a guide for the suggestions that follow, but it must be remembered that lining, ground treatment, and other factors will influence individual requirements. The work was done in a large darkened studio. The room reflection from the distant walls was minimal and was reduced by baffles, 2 feet wide, around the painting.

He utilized a single studio lamp with a 13-inch parabolic reflector and No. 50 photoflash bulbs. The reflector was 2 feet behind the lined, 18 x 22-inch painting.

Experiments with electronic flash units indicate that a studio type lamp at 3 feet, and having a 225 watt-second rating, would have to be fired 1 or 2 times.

For the open-flash method the shutter was opened in the dimly lit room, the bulbs fired, and the shutter closed. Obviously, when the multiple flash method is employed, care must be taken not to jar painting or camera.

COPYING APPLICATIONS

The infrared copying technique has been widely used in numerous applications—often in conjunction with other nondestructive methods of examination, such as ultraviolet photography and radiography. There are two broad categories of applications: (1) investigating illegible documents—censored, deteriorated, or forged (see Figure 24); and (2) examining paintings—genuine, altered, or faked. Many of the applications described in early papers are no longer discussed in the literature because they have become routine. Since the publication of these papers, sensitized materials and processing solutions have been improved, but such changes affect the basic techniques described in them scarcely at all.

At the time of this writing, the experiments discussed in this book have been conducted by means of the black-and-white infrared technique. It is very likely that infrared color photography can be pressed into service to extend much of the work further. The infrared color method is valuable when inks and pigments that appear to have the same color can be differentiated photographically. The following sections review broadly the representative copying work done in various fields and do not pretend to be all inclusive. Some of the applications are pursued further under Specialized Indoor Techniques in sections such as those dealing with photomicrography and infrared luminescence. Particular aspects of technique are given in context. Where technical factors are not included, it can be assumed that only the general procedures already described will be needed.

KODAK WRATTEN Filter No. 87 is usually employed in copying applications. When the photographer feels the need for a stronger infrared effect or greater differential penetration, he can try the No. 87C filter.

ILLEGIBLE DOCUMENTS

The most important application of infrared photography in copying is the deciphering of indistinct writing. The text may have been made illegible by charring; deterioration as a result of age or the accumulation of dirt; obliteration by application of ink by a censor; invisible inks; deliberate chemical bleaching; or mechanical erasure and subsequent overwriting.

Inks and Pigments

Inks, pigments, and other materials that appear identical to the eye are frequently rendered quite differently by an infrared photograph. If an ink transparent to infrared is applied over one opaque to it, the underlying ink will show up in an infrared photograph. (See Figure 24.) The original inks used in writing on

documents that have become blackened may be revealed by infrared photography, although success will depend on the condition of the paper. Typewriting that has been mechanically erased may be revealed in an infrared photograph by virtue of traces of carbon or dye left embedded in paper fibers. Chemically bleached writing often is deciphered by infrared photography if the product resulting from the reaction of the bleach with the ink absorbs more infrared radiation than the surrounding paper. Especially useful results have been obtained in the deciphering of certain falsified documents by photographing infrared luminescence induced by exposure to blue-green light or, in some instances, to ultraviolet radiation. This technique should be tried when the reflection method does not supply all the information hoped for. (See Figure 25.)

Some of the earliest infrared deciphering was done by Bendikson (1932). He utilized infrared photography

FIGURE 24—Panchromatic (top) and infrared (bottom) renditions of a letterhead in pigment-type ink obliterated with a dye-type ink. (Courtesy of the Federal Bureau of Investigation.)

to reveal censored passages in a collection of travel volumes written around 1600. The offending passages had been covered with ink by a member of the Spanish Inquisition. The ink used in the expurgation was transparent to infrared, whereas that employed by the author absorbed infrared. The resulting infrared records revealed the censored lines as clearly as the untouched ones.

Palimpsests, Papyri: The main problem in investigating some of the documents just described, and in making palimpsests legible, lies in the presence of two or more inks. When two inks are involved, the ink applied last either has to be entirely transparent to infrared or has to have some transparency and more infrared reflectance than the ink covered up.

Information on the photographic behavior of inks and pigments is valuable in planning a procedure. Mitchell (1937) and Tholl (1967) present definitive investigations into the response of inks and pigments to various photographic treatments. Among other discoveries, Mitchell found that iron-gall, chrome-logwood, and osmium-pyrogallate inks recorded dark, whereas most vegetable lakes were transparent to infrared. Mitchell also investigated ancient Egyptian pigments and medieval pigments. Tholl's work was largely in ultraviolet investigations; however, it is quite detailed procedurally.

Gosling (1962) presents an intricate but invaluable masking method for separating legends and imprints on documents when one or two sets of detail interfere with another set. Masks are produced that differen-

FIGURE 25—Forgery of a postal-meter stamp. The alteration was invisible to the eye and not recordable by panchromatic or infrared-reflection techniques. **Top:** Panchromatic-reflection record; **bottom:** infrared-emission record. (Courtesy of the United States Postal Service Chicago Crime Laboratory.)

FIGURE 26—Portion of a Dead Sea scroll so badly blackened by aging that the writing was absolutely illegible. **Left:** Panchromatic-reflection photograph; **right:** infrared-reflection photograph. (Courtesy of the Palestine Archaeological Museum.)

tiate between wanted and unwanted information. Sometimes, making an infrared negative mask is the only means of suppressing the unwanted details.

Charred, Aged, and Worn Writings

Documents that have become charred by fire—and those blackened by age, dirt, or stains—can sometimes be deciphered in an infrared print. (See Figures 19 and 26.) Bendikson (1933), Radley (1948), and O'Hara and Osterburg (1949) discuss in detail photographing charred paper. Beardsley (1936) and Coremans (1938) were able to reveal the legends on badly discolored papyri. The investigation of papers surviving wilful attempts to burn them, and of forged documents is discussed by O'Hara and Osterburg (1949), Sternitzky (1955), and Harrison (1958).

Sometimes, wear will obliterate writing so that it can no longer be seen with the naked eye or photographed with panchromatic film. Yet traces may remain that can be picked up by infrared photography. (See Figure 27.)

WORKS OF ART

Infrared photography has taken its place with chemical study and with x-ray and ultraviolet photography as an important means of determining the authenticity of paintings. Pigments vary in the way in which they transmit and reflect infrared, even though they appear identical in color. Infrared photography, therefore, sometimes can be of use in detecting the presence of overpainting and other alterations, and in distinguishing between an original and a later copy. Important factors are the varnish and the medium, which differ in their infrared transparency according to their nature and age. A painting whose varnish has darkened or deteriorated so much that detail can scarcely be seen, may be revealed by infrared photography.

Badly discolored, faded, or dirt-covered photographs, daguerreotypes, engravings, drawings, maps, and other such items, have been successfully photographed by infrared.

Paintings

Much of the work in the examination of paintings deals with primitive natural materials—like linseed and *Phytolacca clavigera* varnishes, *Semecarpus anacardium* pigments, and mineral colors—because they record differently from anilines and modern lacquers. The reader can refer to Clark (1946) for a broad discussion and bibliography, and to Mitchell (1935, 1937) for good accounts of specific experiments. Such a background could be helpful in new work.

The employment of infrared materials in copying old parchment maps under a thick layer of varnish has

FIGURE 27—Knife sheath from among the effects found with an unidentified body. **Top:** Panchromatic record; **bottom:** infrared photograph, which reveals traces of the owner's name, even though it could not be seen because of wear. (Courtesy of the Federal Bureau of Investigation.)

extended the amount of detail revealed. Wehlte (1955) and Hours-Miedan (1957) also discuss the penetration of varnish and dirt on paintings, icons, and panels. Infrared photography offers advantages over ultraviolet photography, because infrared rays do not cause varnish to fluoresce, as ultraviolet rays do.

Many of the uses for infrared photography in the examination of paintings depend on spectral differentiation as well as on penetration. Farnsworth (1938) made an extensive investigation of the gray tones to which several modern pigments photographed—dry, with or without impurities, in various media, and on different surfaces. She included records made in a regular camera with spectroscopic emulsions (see page 3). Differences were often detected photographically that did not appear upon spectrographic analysis; conversely, such analysis frequently showed differences undetected by photography.

As pointed out by Coremans (1938), modern pigments, particularly those derived from aniline, can present a visual appearance similar to that of primitive pigments. In an infrared photograph, however, a marked difference may appear—which makes the establishment of chronology and the nondestructive detection of restoration quite simple. The experiments of Bridgman and Gibson (1963) bear this out. (See Figure 28.)

Wehlte (1955) stressed the importance of photographically examining paintings before any restorative measures or cleaning procedures are begun. The infra-

red photographs establish the condition of the painting. The penetration of varnish, and even the penetration of thin layers of the warmer colors, often indicates the condition of the work. He cites an instance involving an inscription believed to have been overpainted by the artist. Infrared photography provided conclusive information that proved the existence of the legend, indicated the ground upon which it was painted, and thus justified uncovering the text.

Hours-Miedan (1957) points out that works attributed to one artist are often found to carry hidden signatures of another or of a student. Sometimes the name of the patron can be uncovered. Most writers in this field discuss the value of analyzing the style of an artist with the help of infrared photography. One can detect the amount of preliminary sketching done on a canvas, as well as changes in composition made as the artist progressed with the painting. Keck (1941) described in great detail the very complete tracings the American painter Johnson made on his canvases before beginning to paint.

The infrared transirradiation of paintings has been discussed under "Lighting," see page 48. The technique is often a valuable adjunct to reflection photography in revealing design sketching, signatures (especially those on the back of lined paintings), and other subsurface details.

Use of Masking: In order to provide a clear photographic rendition of signatures, sketches, and other fine detail, subtractive and diffuse masking methods can be employed. The positive mask is made from a red-filter negative and is superimposed over an infrared negative in order to cancel out the general tone gradations common to both. This leaves the fine detail, present only in the infrared negative, unobscured for printing at high contrast. Thin-lined black crosses on small patches of white paper are temporarily attached to the corners of the painting. This is done not only to aid in registering the mask but also to ensure negatives made at the same magnification. The red-filter negative is made first. The camera is then refocused and an allowance, found by previous trial, is made to reduce

FIGURE 28—Samples of modern artists' pigments. **Left:** Panchromatic rendition; **right:** infrared-reflection rendition; **bottom:** infrared-luminescence rendition. **Key:** Greens—**cH,** chrome; **cR,** Hansa yellow; **V,** viridian. Blues—**cE,** cerulean; **U,** ultramarine; **cO,** cobalt. Reds—**A,** alizarine; **cA,** cadmium; **R,** rose madder. Whites—**L,** lead; **T,** titanium; **Z,** zinc.
 Note the transparency of **"A"** to infrared as well as the infrared-reflection characteristics of the various paints; also observe the high emission of **"cA"** and the moderate effect with **"R."**

FIGURE 29—Paintings by the 18th century Spanish artist Diego Velazquez reveal hidden evidence of the artist's technique with examination by infrared photography and radiography. The photographic investigations help to substantiate the theory that Velazquez did not always use preliminary drawings but instead altered the position of an object or figure simply by painting over it. The four illustrations at the right show comparisons of **(a)** a visible record on panchromatic film, **(b)** an infrared reflectance record made on KODAK High Speed Infrared Film through a KODAK WRATTEN Gelatin Filter No. 87C, **(c)** an x-ray record made on a Kodak radiographic film, and **(d)** a schematic drawing showing the differences revealed (dotted line outlining the visible record and solid line outlining the infrared features). Professor Andrew Davidhazy of the Rochester Institute of Technology made these comparison photographs of Velazquez' "The Forge of Vulcan" at the Prado Museum in Madrid. (These photographs are used with the permission of Prof. Davidhazy and through the cooperation of the Prado Museum and Dr. Gridley McKim-Smith, art historian, of Tulane University.)

a. Visible record

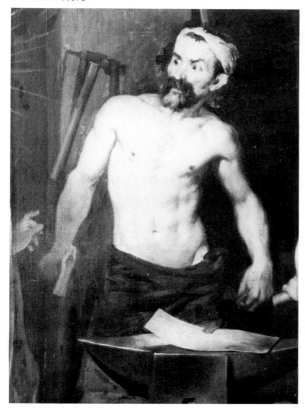

b. Infrared record

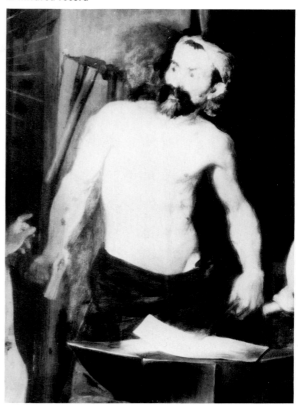

c. X-ray record

d. Schematic outline comparison

53

FIGURE 30—Museum research can be aided by infrared photography. **Top left:** There was no visible clue to identify the owner of this United States regulation canteen; **top right:** the infrared-reflection photograph revealed the complete markings. (Specimen courtesy of Livingston County Historical Society.) **Bottom left:** The trace of markings below "122" were most likely to be "CSA," but could have been "USA," or some other initials marked on by a soldier; **bottom right:** the infrared-luminescence investigation proved conclusively that the canteen had been relabeled "CSA." (Specimen courtesy of West Point Museum.)

the scale of the infrared negative to fit that of the red-filter negative.

Museum and Forensic Objects

While some artifacts could also be considered three-dimensional subjects instead of two-dimensional, they will be discussed here because copying lighting is almost always employed.

Fabrics are often studied by museum curators. Coremans (1938) for example, explained how areas of restoration on tapestries can be detected because of differing infrared reflectances of primitive and aniline dyes. Also, the tarnishing of the silver component in gold thread in ornate textiles will sometimes leave traces recordable by infrared photography, even after the gold thread has been filched.

Milanesi (1963) illustrated how infrared photography could serve as a valuable adjunct to radiography in dating, classifying, and assembling prehistoric and protohistoric pottery fragments. Radiography revealed the nature of the clay body and vertical and horizontal radii of curvature; infrared photography indicated the character and direction of designs invisible to the eye.

Coremans (1938) illustrated how well infrared penetrated the patina and saline encrustations covering a carbon-ink inscription on a calcareous stone fragment. Another experiment revealed a shell drawing hidden under a thick, resinous crust.

Infrared photography has proven invaluable in making writing and stencilled markings on American Civil War canteens legible. Figure 30 indicates that such details were scarcely observable on the fabric cover. Both infrared-reflection and infrared-emission techniques contributed information unobtainable by other means.

SPECIMEN APPLICATIONS

The same general remarks that prefaced the section on specific copying applications apply here. However, some work in infrared color photography has been done with biological subjects (Gibson *et al,* 1965); hence, this technique now comes into prominence.

Veterinary investigations and some phases of photographing laboratory animals call for the techniques of medical infrared photography, because when the animal is depilated, its skin or body can be photographed by the same infrared techniques that are used to photograph human subjects. These techniques are covered in Kodak Publication No. N-1, *Medical Infrared Photography.*

ZOOLOGICAL SPECIMENS

Pigments

Mitchell (1935) discovered that fossil sepia (from *Acanthoteuthis sp.,* Oxford clay) and pigment from the present-day *Sepia officinalis* behaved as though eons did not stand between their origins—both are opaque to infrared. He postulates, as a result of this finding, that the lack of marked infrared absorption by Negro skin—observed in black-and-white infrared photography—may result from scattering by epidermal tissues around the fine melanin particles. He believes that isolated melanin might absorb like sepia, and points out that pigments in furs are photographed dark, probably because scatter is blocked by the opacity of the hair roots.

It has been found, however, that Negro skin exhibits the red color of melanin in infrared color photography (Gibson *et al,* 1965). This suggests that any scattering factor in the epidermis is very slight, because when structures containing melanin are photographed under a scattering layer, they record dark blue by infrared color photography. Examples are the shaved stubble of the human beard and the melanophores in the deeper layers of leopard-frog skin (Gibson *et al,* 1965). See Color Plate III.

Other pigments found by Mitchell to record dark are the spots on frogs and the black stripes on mackerel by black-and-white infrared photography. Many green caterpillars photograph to the same tone as leaves in a black-and-white infrared photograph, yet record in a different hue in a color infrared photograph (Gibson, *et al,* 1965). See Color Plate III.

Massopust (1952) showed how infrared radiation could penetrate amniotic membranes to reveal details in animal fetuses.

Combined Infrared and Color Photography

One investigator produced informative color photographs of a sea horse and a tsetse fly by means of "black-and-white" infrared negatives developed in a "chromagenic" developer. The infrared negatives were put in juxtaposition with color negatives for printing onto photographic color paper. The infrared records provided internal details because of the penetration of chitin; the color negatives supplied the surface details. The combination offered much more information than could be obtained from either type of record alone.

Combined Infrared Recording and Radiography

An unusual application of black-and-white infrared photography was presented by Massopust (1936b). By placing biological specimens (large moth and frog) upon films in a lighttight box, he produced "contact prints." The radiations used were infrared and diagnostic x-rays. The resulting photograph was quite like a grenz-ray radiograph, although some of the surface details that were recorded would be absent in a radiograph. The technique could be useful on occasions when a soft x-ray tube is not available. The harder x-radiation delineates the dense regions like bones, and the infrared radiation produces detail in the soft tissues and the surface.

Protein Suspensions

Miller (1952) discussed a special lamp for electrophoresis. Treffers and Moore (1941) outlined the value of infrared photography in obtaining recordings in the ultra-centrifuge.

BOTANICAL SPECIMENS

Specimens for many of the studies described under outdoor photography in plant pathology can often be brought indoors. In Plate II, the infrared color rendition of the magnolia twigs of Figure 8 is shown. The photography was done outdoors. In Plate III, a rose leaflet infected with black-spot fungus is depicted. It

was more convenient to make this photograph indoors than outdoors. With this specimen infrared color photography gave additional information to that obtainable from a black-and-white infrared photograph.

Plant Pathology

Bawden (1933) illustrated the results he obtained with potato and tobacco leaves carrying streak diseases and virus X. Regardless of the causative virus, hardly visible lesions on necrosing potato leaves could be readily recorded by black-and-white infrared photography. They could not be detected by panchromatic photography. In contrast, infected tobacco leaves behaved in the opposite way—they were detectable by panchromatic but not by infrared photography. On the other hand, the lesions of tobacco ringspot did lend themselves to infrared recording. Upon investigation, Bawden found that necrotic areas involving empty cells devoid of chlorophyll permitted infrared to be reflected from the leaf structure, just like healthy leaves. When disease fills the spaces of the destroyed cells with pectic substances with tannin and with other breakdown products, infrared is absorbed and thus prevented from reaching the reflective cell walls.

Gibson (1967) illustrated laboratory methods of infrared photography with an investigation of the unusually high degree of infrared absorption he found in a black, rotted area on a cactus plant. This was discovered when an unaccountable stain was noted in the infrared record of another specimen. His paper describes the step-by-step photographic procedures of investigative infrared photography that traced the stain to the rotted cactus. The cause of the black rot was not known. However, Mitchell (1935) had stated that the gills of mushrooms are opaque to infrared, but gave no comparative data that might be correlated with the cactus-rot experiments. Mitchell's finding does suggest that the rot might have been due to a fungus rather than to a virus or bacterium. Figure 31 compares the high infrared absorption of the rotted cactus with that of graphite, which is considered to be a good absorber of infrared.

Jackson (1964) outlined an extensive project to implement the detection of plant-disease symptoms by means of infrared photography. He studied the spectral absorptions of many healthy and diseased leaves, and diagrammed leaf structure to explain the various tones of gray obtained in infrared photography. Because of water content and other factors, even healthy leaves absorb infrared radiation having a wavelength longer than 900 nanometers. He concludes, therefore, that the 700 to 900 nm sensitivity range of ordinary infrared film is an efficient one in which to work when studying foliage. His illustrations show the efficiency of infrared photography in mapping chlorotic and other areas caused by bacterial infection. He also shows how the degree of reflection exhibited by leaf tissue is not affected by drying. However, in some conditions, the damaged spots absorb infrared to a greater extent when the leaves are dried—enabling the pathologic areas to stand out in better contrast in the infrared photograph.

Lignum Studies

Several investigations have been conducted into the properties and identification of various woods. In experiments here we photographed a cane clarinet reed

FIGURE 31—Two photographs that demonstrate a method of comparing infrared absorption in photographic investigations. **Left:** Visual appearance of a graphite brush from an electric motor and a piece of rotted cactus pulp. The rectangle of black paper was wetted with water, the other paper with juice from the cactus pulp. **Right:** The infrared photograph shows that the paper had a high infrared reflectance, the graphite a moderate reflectance, and the pulp a high absorption. Note that the tissue of the pulp, rather than the juice, is responsible for this absorption.

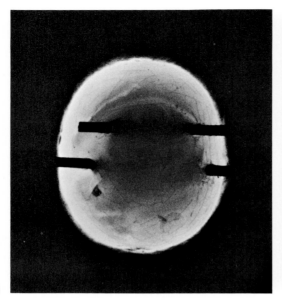

a

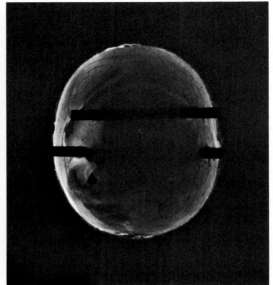

b

c

FIGURE 32—Panchromatic-, **a,** and infrared-, **b,** transmission records of a cloudy Baltic amber bead are compared with an infrared-luminescence photograph of the bead, **c.** Graphite pencil leads, 0.10 and 0.17 inches below the surface, served as a penetrameter.

and found that it offered almost equal degrees of visible and infrared translucency. The compact structure of the reed was readily demonstrated by infrared photography.

In another experiment (Gibson, 1962), it was found possible to penetrate the knot shown in Figure 2 by the reflection technique to the extent of showing the shadow of the top screw, but not of the lower one. Figure 32 shows a similar test object; an amber bead, with pencil leads buried at various depths to provide a penetrameter. There is reflection, but little revealing penetration, due to scatter from the turbidity of the amber. Under transillumination the knot and the bead transmitted both visible light and infrared, the latter process being relatively stronger. The same was true of clear Baltic amber. Some visible, dark-toned, unrecognizable specks in the clear specimens disappeared in the infrared records. They were probably tiny insects or insect debris—chitin is quite transparent to infrared.

FOSSILS AND SEDIMENTS

Infrared-reflection photography has advantages in delineating certain fossils in addition to the promise shown by the luminescence method. Most of the work reported deals with fossils associated with coal. The lignin layer can be penetrated (Walton, 1935). Other coal components provide not only permeability but also lend themselves to spectral differentiation. This is particularly true, Eggert found, with paleobotanic specimens, where fossilized leaves record in light tones like live leaves do. Harris and Latham (1951) showed a series of interesting comparison infrared photographs of a fossil in Caithness, micaceous flagstone. Their best result came from utilizing a polarizing filter. The mechanisms that produced good results with the polarizing filter were probably the penetration of mica and the partial subduing of glaring catchlights from the platelets. These authors stated that Cleveland shale behaved in the same way.

Several experiments with carbonaceous fossils were carried out in our scientific photography laboratory.

We found that they photographed just as dark in a panchromatic record as in an infrared one. A fossil cockroach (*Etablattina sp.*) in underclay, for example, was just as clear (or indistinct) in both records. Some characteristics of certain matrices, however, may provide tone separation. For instance, specimens from the Green River formation are quite glaring visually; under infrared the very white areas are toned down. The procedure to adopt in these and in similar experiments, as is so often the case, is that of making a series of trial photographs. The potentiality of infrared photography often cannot be predicted.

Sectioned Cores

Rhoads and Stanley (1946) found that the infrared photography of sections of sediments cut to less than 6mm thick revealed definitive information on stratification, animal burrows, and grain size. This was in addition to the information obtained by x-radiography and other methods. Slight differences in organic content were very susceptible to infrared detection. This method also had the advantage of being quick and simple. Consolidated sediments were merely sectioned. Unconsolidated material was saturated with water, frozen, extruded, cut, thawed, and then bound with water-soluble expoxy resin. Once bound, sections were further trimmed to a suitable thickness for transillumination photography.

Rolfe (1956) presents valuable applications of infrared photography in paleontology.

PREPARATION AND ARRANGEMENT OF SPECIMENS

It is axiomatic to state that the area of interest must be presented to the camera, but it should be pointed out that the main surface ought to be perpendicular to the subject-lens axis. Animals may have to be restrained in order to accomplish this. In some experiments, anesthetization can be helpful; however, such an expedient might cause physiological changes that would invalidate the results of certain investigations. For recording the superficial circulation of furred animals, they have to be depilated.

The three-dimensional shapes of infrared subjects are almost never of consequence. When the area of interest is presented squarely toward the camera, depth-of-field requirements are minimized. Leaves can be flattened with thin glass if necessary. For close-up records, stems bearing whorled leaves may have to be trimmed to leave only the lateral blades.

Controls, like a healthy leaf or a luminescing standard must often be included. Some special preparations may be needed, depending on the nature of the information being sought. Massopust (1934) placed anatomical gross specimens under oil of wintergreen.

Harris and Latham (1951) found that immersing Caithness (micaceous) flagstone and Cleveland shale fossils in monobromonaphthalene improved the infrared contrast between the fossil and the matrix. This liquid has approximately the same refractive index as the mica platelets, so that strong specular reflections from the superficial rock grains were reduced and did not obscure the absorption of the infrared rays penetrating to the fossil. The handling of sediments has been discussed above.

SPECIALIZED INDOOR TECHNIQUES

A wide range of applications are available; they cut across many disciplines. Hence the techniques will be treated in sections and the fields outlined in each section. Discussions of pertinent equipment are included to supplement information previously given.

PHOTOGRAPHS IN DARKNESS

The capability of making infrared photographs "in the dark" offers opportunities for three major types of investigation: (1) studying human and animal behavior without influencing it by causing awareness of the camera or without invalidating the experiment by disturbing the light-dark cycle; (2) pupillography, in which eye responses can be recorded without interference from the photographic light source; (3) surveillance in law enforcement, in which evidence can be gathered without the knowledge of those committing the offenses.

All these applications depend upon the well-established fact that mammalian vision does not extend to the infrared. Gibson (1948) found that tropical fishes, too, are blind to infrared rays through ½ inch of water. A simple way to determine this photographically is illustrated in Figure 33. The procedure is based on the reaction of fish tested when they were under a focused beam of white light under low ambient illumination. When the beam was angled to the vertical, the fish tilted toward the beam in such a way that their normally horizontal interocular plane became perpendicular to the beam. When color filters were placed in the beam the fish could be tilted also. But when a KODAK WRATTEN Filter No. 87 was placed over the light, they did not exhibit a reaction. This indicated that the fish did not perceive infrared.

Recording Human Behavior

It is relatively simple to rig infrared photoflash setups, or to utilize them in flashguns, to make still photographs in the dark. Human subjects can be photographed without their realizing it. This is of special value in trapping burglars at safes, cash drawers, etc.

For photographic traps and for many laboratory setups, cameras usually have to be preset and the flash fired by circuits triggered with infrared detectors. It is necessary, however, for the photographer to know where his subject is going to be. No lens filter is needed.

The use of coated flashbulbs entails some precaution when photographic traps are rigged. A dull red glow may be visible, especially if the subject happens to be looking in the direction of the flash. Visibility can be reduced by directing the flashholder toward a light-toned wall or ceiling to provide bounce irradiation and to preclude direct viewing by the subject.

The maximum working distance indoors for an infrared-coated No. 5R lamp, KODAK High Speed Infrared Film and an $f/3.5$ lens is 60 feet. The approximate distance must be decided beforehand, and the focusing scale set accordingly. The lens diaphragm must also be set according to a guide-number calculation involving this distance: Divide the appropriate flash exposure guide number by the lens-to-subject distance to find the f-number of the lens opening.

When a great many infrared flash pictures are to be taken, or when infrared-coated flashbulbs are not available, the photographer can use a gelatin or glass filter; see page 26. A piece of KODAK WRATTEN Filter No. 87 or 87C can be purchased in a size large enough to cover the front of the flash reflector and can be taped to a single piece of clear glass or sandwiched between two pieces of glass for protection. Since optical quality is not required for this light-source filter, the gelatin filter taped to ordinary glass suffices. A lighttight housing can be devised to hold this filter on the flash gun. Naturally, the housing should be easy to open so that flashbulbs can be changed after each exposure. Using clear No. 5 or 25 bulbs with a No. 87 filter will result in flash exposure guide numbers of the same range as those given for No. 5R coated lamps used without a filter. The No. 87C filter gives no tell-tale glow, but it necessitates 2½ stops more exposure.

Electronic flash units can be used similarly, and since the lamp does not have to be replaced after each exposure, the filter holder can be simpler. The filter can even be taped over the reflector or held in place with rubber bands. Guide numbers here are easily determined by the user with a simple trial exposure series. Most of the portable low-voltage units (around 500 volts) yield guide numbers in the 200 to 300 range with KODAK High Speed Infrared Films.

In contrast to the "camera-trap" applications involving still photography, most human behavioral

FIGURE 33—Regular photography is often useful for documenting the results of infrared research. This record shows a simple method for testing the infrared perception of a fish. The specimen at the top was tilting toward the beam of a pocket flashlight over which a red filter had been placed; the fish at the bottom was at a normal angle because it was outside the beam. A synchronized photoflash exposure was made in dim light. When an infrared filter was substituted for the red one, no response could be elicited, even when the fish was 1/2 inch from the surface.

studies require cinematographic records to be meaningful. Here too, a hidden camera is used. Kantor (1955) goes into detail about a typical experimental setup. The room was 20 by 13 feet, with a 10-foot ceiling, and seated 25 people. Nine bullet-type light fixtures, in three rows, were mounted on the ceiling. To establish a suitable lighting, these lights, with ordinary service bulbs in them, were aimed and fixed in a position to provide even illumination over the prospective audience. The reflectors were directed at 45 degrees downward into the faces of the viewers to preclude contrasty shadows of overhead lighting.

For photography, 150-watt projector-flood lamps were utilized. These were coated with an infrared filter mixture (the formula was given). This coating lasted for about 1 hour of filming. No filter was used over the camera lens; in this way, both the infrared radiation and the light from the projector reflected from the screen contributed to the exposure.

With KODAK High Speed Infrared Films, an aperture of $f/4$, and the shutter set at 235 degrees, the camera could be run at 24 frames per second, in the setup described above.

Greenhill (1955) described how to reduce the film consumption required for an extended period of motion-picture recording. The camera was run at 1 frame per second. This speed increased the shutter-open time to 1/12 second. Only two 250-watt reflector infrared heat lamps were needed to irradiate a 14 by 24-foot room with a light-toned ceiling; the lens aperture was $f/2.8$. The lamps were directed toward the ceiling from each side of the screen. The audiences could see the dull red glow of the lights, of course, but thought it was part of the decorative scheme. In a later paper (1962), Greenhill gave refinements of the technique and discussed its application to the photography of animals.

Photographing Animal Behavior

Another branch of investigation is the photography of the behavior of laboratory or wild aminals in the dark. Some of this investigation can be done with panchromatic photography by intermittent flashes. However, one is never sure that the visible flashes do not disturb the subjects. In fact, in our experience we have found that some spiders become quite "neurotic" in their behavior when photographic flashes interrupt their nocturnal web-building activities. Infrared photography offers a practical solution.

In the Forest Insect Laboratory of the Department of Forestry (Canada), the nocturnal habits of mice and shrews have been studied. An infrared filter was placed over the light source and a motion-picture camera was utilized to make, essentially, a series of still photo-

graphs that could be analyzed to plot the creatures' movements. An animal triggered the light, time recorder, and time-lapse equipment when it emerged to feed. Automatic, spring-driven, 35 mm still cameras can be utilized for this type of study when only a short span of time is involved.

It is necessary to focus the camera in bright light in

FIGURE 34—Changes in pupillary diameter of a laboratory rat, photographed in the dark on infrared film. (Pupillograms courtesy of Drs. O. Lowenstein and I. E. Loewenfeld.)

such a way as to encompass, within the depth of field of the lens, the confined arena of action. An infrared beam and a photocell, or an infrared detector, are means that suggest themselves for triggering an electronic flash unit when a subject is in the right place. Suitable lighting can be arranged and exposures worked out with dead animals or other dummy subjects. Much of this work encroaches on the realm of cinematography, but only in the sense that a motion-picture camera is employed.

Facto and Catron (1961) provide a good introduction into the general photographic methods of studying animal behavior. The lighting details already described in connection with still photography in law enforcement can be applied to some investigations involving animals.

Cinematography: Making motion pictures in the dark is another informative technique. With a high-speed (slow-motion) camera, Rieck (1964) photographed the flight of bats in the dark, but gave no details as to how the animals were induced to fly in front of the camera. It is possible to arrange infrared detectors in interlocking gangs that will trigger a circuit when activated from the right direction. In this way, out of many random flights, the desired passage could be selected for recording. Because of mechanical lags, however, this method does not lend itself to starting a camera; it is only practical for firing an electronic flash in an open-flash setup. The most intriguing aspect of Rieck's experiment was the recording of a bat's cries in "slow motion." Thus, sound too high-pitched to hear was reduced in frequency to the audible range, and could be correlated with slow-motion cinematography of action too fast to see (even were it to take place in the light).

The camera speed Rieck employed was 480 frames per second and the projector was run at 24 frames per second. Taping was done at 190 cm per second; the play-back speed was 9.5 cm per second.

The author describes a lighting setup of heroic proportions for this work in high-speed photography. Those contemplating projects of this nature could well consult with manufacturers of electronic flash equipment. Repetitive-flash units are available that would be easier to filter and would present less problems from heat.

For filming at regular speed Rieck (1954) described a setup to light laboratory animals and fish for infrared motion pictures. He studied the fighting habits of mice and certain fish. Rieck enclosed 500-watt spotlights in well-ventilated housings. These housings were fitted with double glass windows sandwiching sheets of

gelatin filter (similar to KODAK WRATTEN Filter No. 88A). Because of the heat, these filters lasted only for one run.

His setups varied from four to six lights; for fish, two additional lamps of 1000 watts each were directed down to the top of the tank. Lamps were 40 to 100 cm from the subjects. Fields were 5 to 75 cm wide. Light intensities, without the infrared filters, ranged from 10,000 to 35,000 lux. The subjects could be just observed for activity by the dull red glow transmitted by the filters. Care had to be taken not to overheat the aquarium.

At 24 frames per second, filming was done at f/2.8 to f/4, in the setup above.

Griffin (1958) describes and diagrams a setup for the electronic flash photography of bats. He employed white light in extremely short pulses—30 to the second—rather than the steady irradiation of Rieck. For any experiment in which light is considered a disturbing influence, it would be easy to place infrared filters over the lights in a setup similar to Griffin's.

Pupillography

This is a most extensive field, and has been employed to study numerous physical and physiological effects in humans and animals. Dark adaptation, visibility curves, accommodation time, response to flash stimuli, the inadequate and auditory stimuli, the so-called third Purkinje image, the effects of drugs, and fatigue are among the phenomena investigated. (See Figure 34.) Again, much of the photography was done with cine cameras used to make a series of still records.

Typical discussions of photographic, stimulation, and conditioning equipment are given in Lowenstein and Friedman (1942), Wagman and Gullberg (1942),

Fugate (1954), Wulfeck (1955), Lowenstein (1956), and Hess (1965). The lights employed for photography usually have been tungsten lamps in housings faced with various infrared filters. Exposures were often long. New work could well take advantage of fast infrared emulsions and the speed, convenience, and coolness of repetitive electronic flash units.

For descriptions of pupillography as it applies specifically to animals, the following references should be consulted: Lowenstein and Loewenfeld (1950a,b) and Loewenfeld (1958).

Focusing: When a photographer focuses on an eye, his impulse is to focus on the detail in the iris. However, the visual focus has to be about in the plane of the anterior pole of the cornea (where there is no detail) for 1:1 infrared photography of the iris or pupil. With human subjects, this can be achieved when the lids are almost shut by focusing on the gray line at the rear edge of the lids. Of course, when the pupil is to be photographed behind a corneal opacity showing detail, the cornea can be in sharp visual focus. The depth of field attainable will usually cover reasonably slight deficiencies.

PHOTOGRAPHY IN LAW ENFORCEMENT

In the field of criminology, infrared photography has found many applications. They include detection and deciphering of erasures and forgeries; deciphering of charred documents or those which have become illegible as the result of age or abuse; differentiation between inks, dyes, and pigments which are visually identical but which represent different compounds; detection of gunshot-powder burns, stains, and irregularities in cloth (see Figure 35); examination of cloth, fibers, and hair which are dyed too dark to be easy to

FIGURE 35—From the visual appearance (left) of this garment it was not possible to determine the cause of the hole in it. The infrared photograph (right) reveals the powder and burn marks of a firearm. (Courtesy of Police Department, New York, New York.)

FIGURE 36—Youthful burglars photographed by a hidden camera with infrared illumination.

study by visible radiation; study of fingerprints; examination of the contents of sealed envelopes; detection of certain kinds of secret writing; determination of carbon monoxide impregnation of victims of gas poisoning; photography in the dark (see Figure 36).

Sources of Information

The techniques for photographing documents and specimens have already been discussed. (See page 53.) References have been indicated. The above sections dealing with photography in the dark also contain information pertinent to surveillance. Kodak Publications M-2, *Using Photography to Preserve Evidence,* and M-8, *Photographic Surveillance Techniques for Law Enforcement Agencies,* contain specific information for those employing photography in law enforcement.

PHOTOMICROGRAPHY

Investigation into the applications and techniques of infrared photomicrography was done early. The later literature sometimes uses the records without going into fundamentals of the technique. Also, microradiography with soft x-rays serves to reveal details in many specimens once penetrated by means of infrared pho-

tography. (See Mitchell and Graham, 1958, for an extensive presentation of this radiographic technique.) New avenues have been opened up by the use of heat sensors in the long-wave infrared region; they do not involve direct infrared recording. (See Maresh, 1953, Nomarski, 1955, and *Anon,* 1963.) Nevertheless, there are still many fields in which infrared photography can be found simple and useful; see Shillaber (1949).

In 1932, Kraft worked with Lower Silurian graptolites and found that even the carbonized chitin remains could be penetrated by infrared to show detail. Many other carbonized fossil remains, such as fish scales and animal hairs, also lent themselves to infrared photography. Insect carapaces and pollen grains were transparent to infrared, while a bitumen matrix was opaque. Klinger (1934) was able to deduce data on the formation temperature of coals from the infrared photomicrographic renditions of rosin structure.

The keratin of human and other hairs, and the dark chitin of insects and arthropods, can be penetrated by infrared radiation. (See Figures 37 and 38.) Prát (1936) found that invisible or scarcely visible cellular detail in present-day plant structures, such as rhizoids and sporangia, become distinct in the infrared photomicrograph. Pigments in chloroplasts absorb visible light but pass infrared. He (1935) recorded new detail in plant chromosomes. Fowler and Harlow (1940) studied the wall structure of plant cells.

In animal histology, Preissecker (1931) illustrated the additional detail yielded by the technique, especially in dark reds. Blair and Davies (1933) applied it to delineating neurohistological sections stained with silver nitrate. Massopust (1934) worked with brownish and reddish areas in kidney sections, and with injected specimens of the human fetal eye, as well as with entire animal embryos. In all these applications, black-and-white infrared photography gathered information that could not be obtained by visual observation or regular photographic methods.

Massopust (1936a), by omitting the usual infrared filter, obtained excellent photomicrographs of muscle and kidney sections. Such photographs combine a sharp image in the blue (to which infrared film is sensitive) with an infrared image. He also investigated bone sections and the visually opaque melanin deposits in eye sections cut through the iris. Gibson (1963d) did some infrared photomicrography with tooth sections.

Gibson, *et al* (1965), showed how silver sulfide and melanin granules could be distinguished in an infrared color transparency. (See Plate III.) They also discussed how infrared color photography can be used in detecting autoradiographic silver and possibly in differentiating inclusions in lung sections. Gibson (1965)

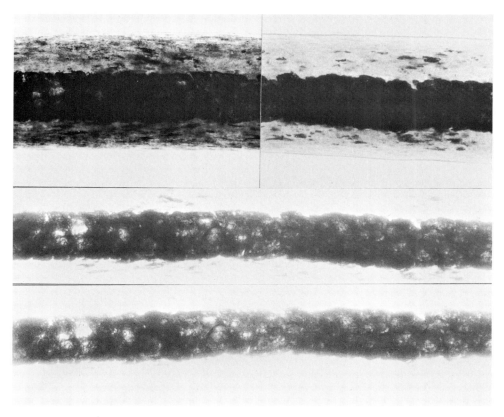

FIGURE 37—**Top left:** Photomicrograph on panchromatic film of a human hair; **right:** the same hair photographed on infrared film. Note how infrared penetrated the keratin. **Center, bottom:** Panchromatic and infrared renditions, respectively, printed to the same maximum density for the medulla. Note that here, too, infrared penetrated to a somewhat greater extent than white light was able to do.

photographed living, oxygenated red blood cells at ×200 with infrared color film and found a color quite similar to that of arterial blood *in vivo.* Possibilities for studying oxygen transfer in a thin capillary bed are thus afforded by infrared color photomicrography. When the records are made at moderate magnification to preclude marked diffraction and depth-of-field color fringes, a difference in color should be noticeable between oxygenated and nonoxygenated red blood cells or blood streams.

At the 1967 annual meeting of the American Society of Clinical Pathologists and the College of American Pathologists, Schneider and Legowik reported that they had found infrared color photography to be of great assistance in histology. The photographs offered valuable new information on differentiating biologic pigments, tissue structures, inclusions, and histological stains. A note by Casida (1968) described new findings. He was able to photograph both living and dead unstained bacteria in a contrasting red on infrared color film. They were well separated from other materials, such as earth particles and organic struc-

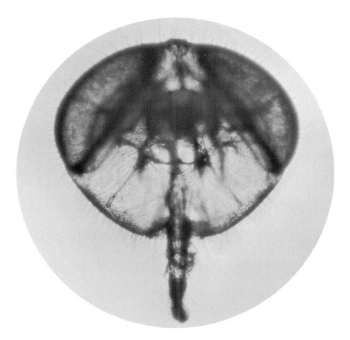

FIGURE 38—The head of a house fly, photographed on infrared film to demonstrate the penetration of chitin. In the comparable panchromatic photomicrograph, all but the lightest areas were black and no detail could be recorded in the dense parts.

tures, on the slides. He added that the technique could be useful in extraterrestrial investigations into the presence of bacteria.

Indirect Photomicrography

Maresh (1953) experimented with an infrared microscope coupled to an electron image-converter tube. (Such a device is also described in a later note; see *Anon,* 1963.) Maresh worked with radiation having a wavelength of 1300 nm. His magnifications were around × 600. He was able to reveal the pores under the scales of a moth wing and to obtain fine detail in the visually opaque elytrum of a metallic woodboring beetle. With the same equipment, much valuable work was done with ballpoint inks and other dye dispersions. One problem was that a dispersion of phthalocyanine blue pigment, made dilute enough for visual study, was not representative enough of practical dispersions. Good dispersions, however, could be photographed by means of his technique.

Photomicrographic Techniques

A pulsed-xenon arc provides satisfactory illumination for infrared color film. Quartz-iodine lamps have also proved suitable. The sources commonly employed for black-and-white photomicrography are suitable for black-and-white infrared work. Red or opaque filters are needed in the light beam for black-and-white photography, but are not necessary in the color technique. Of course, the usual yellow filter is needed. Since infrared color film is quite fast, it may be necessary to reduce the light intensity with neutral density filters. The required amount of neutral density should be made up from carbon and silver filters. (See page 27.) The density proportion should be two silver to one carbon in order to keep the color balance of the illumination adjusted to color film. Electronic flash units should be useful in color work.

Focusing: To focus the microscope for infrared color photography is not difficult, because no visually opaque filter is involved and much of the image is formed in the visible region. For black-and-white photomicrography, more care is needed because the image is an infrared one; microscope optics are not corrected for radiation in this region. In general, apochromatic objectives will yield a sharper image than achromats.

One method of focusing for black-and-white photomicrography involves the use of a KODAK WRATTEN Filter No. 29—red—in the light path. After careful visual focus is achieved through this filter, it is replaced by a KODAK WRATTEN Filter No. 87—infrared.

Should the optical system of the individual microscope not lend itself closely enough to focusing by the above procedure, calibration with the fine adjustment must be made. This can be simplified by approximating the correction needed with the aid of visual determinations. A KODAK WRATTREN Filter No. 61—green—is placed in the illumination system; the visual focus is found; and the fine-adjustment reading is noted. These steps are repeated to find the index number required with the No. 29 filter. The additional fine-adjustment shift, to be extended from the red index to achieve infrared focus, is then the difference between the green and red settings multiplied by 2 for apochromats, and by 1.4 for achromats. Table IX gives an example. To avoid the effects of backlash, the adjustment knob should be turned *each time,* in the direction from green to red focus, as the index numbers are sought or set.

TABLE IX

	Example of Fine-Adjustment Shift for Apochromat			
	Green	Red	Red minus Green	Infrared
Index Settings	8	13	5 (x 2)	23

After the correction has been found, a filter (green or red) should be selected to be employed during the focusing of a given specimen. The choice will depend on which filter furnishes the visual focus more readily. Thus, the infrared extension can be made from either the green or red index, but the number to be set must be established as indicated above. Of course, the filter used for focusing should be removed before the infrared filter is introduced for the exposure.

It is well to make a few trial exposures around the infrared index so found. From the results, it will be possible to arrive at an individual final correction. Each objective will have to be calibrated separately.

Infrared Color Photography

In our biological photographic laboratory we made some limited but basic experiments with the two most commonly useful light sources—the xenon arc (with a phase contrast microscope) and the quartz halogen bulb (with an ordinary microscope). In both instances the heat-absorbing glass in the lamp was allowed to remain, since it transmits much of the actinic infrared. And, of course, the KODAK WRATTEN Filter No. 12 was put in the beam.

For the xenon arc, a KODAK Color Compensating Filter CC50R (red) was needed in order to balanced the illumination for achieving a reasonably neutral background. (See Plate IV, inside back cover.) The quartz-halogen lamp necessitated the use of a CC50C-2 (cyan) filter and a CC20R filter. Generally, no filter for raising the color temperature to that of daylight should be employed with tungsten lamps, since most of its effect

would be offset by the No. 12 filter, and the green transmission would degrade the results. Yet such filters can be tried for special differentiation. One worker utilized a 6-volt ribbon filament lamp and No. 12, 80A, and 82A filters for studying unstained fungal preparations in water mounts under brightfield illumination. (See Table X.) No heat absorbing glass was in the lamp.

The photographer can adjust his own balance for these lamps and for other tungsten sources by introducing trial filters into the setup. The color-translation effect of the film should be kept in mind. Green filters introduce magenta; red filters, yellow; and excess infrared, red. When the background appears too blue in a transparency, there has been too much green transmission (red and infrared absorption) in the optics or heat-absorbing glass. A red color compensating filter reduces this blueness. A purple background indicates too much green and infrared. The infrared can be reduced with a cyan-2 filter; then both its green effect and the effect of the original excess green can be eliminated with a suitable red color compensating filter. (See Plate IV.)

When the background records greenish, there probably has been too much red, either in a yellowish mounting medium or in diffused stain. This can be reduced with a cyan (not cyan-2) color compensating filter. A brownish background results when the infrared and red predominate. The cyan-2 filter regulates this effect. The use of an orange filter instead of the KODAK WRATTEN Filter No. 12 (yellow),or the presence of yellowish serum, will usually result in a yellow-brown background.

In order to classify or evaluate recorded colors, it is necessary to first adjust the color balance of the illumination as described above. Table X lists some of the colors that can be expected.

When working with our semiautomatic camera having a through-the-lens integrating exposure circuit, it was found necessary to set the speed dial on 200 for KODAK EKTACHROME Infrared Film. The filters were in place when the meter in the instrument was activated. Since meter elements vary in their relative response to color and infrared, it is necessary to calibrate individual equipment.

Once a filter balance and exposure rating have been established in any setup, photography becomes straightforward for a series of similar specimens. When varied slides are photographed, it is necessary to judge whether particular filters may be necessary. Should the results indicate the need for an adjustment in color balance, Table XI can be consulted. Also see "For Color Evaluation," page 28. The filter combination found

suitable can be written on the slide label for future or comparable photomicrography.

TABLE X

Modified Colors in Which Representative Photomicrographic (Transmission) Subjects Are Recorded

Specimen	Modified Color
Silver (autoradiographic)	Black
Silver sulphide granules	Brown
Melanin granules	Red-brown
Black melanophores (frog skin)	Red-brown
Chitin (arthropods)	Red-brown
Hemosiderin (liver, unstained)	Green
Erythrocites: Oxygenated (living) Reduced	Yellow-green Purple-brown
Leaf, parenchyma	Blue
Leaf, green pigment	Magenta
Protozoa	Red (edges)
Bacteria: (sp. unknown) on epithelial cell	Orange
Earth grains	White, various
Fungal specimens pathogenic to man	Red cell walls and septa; blue contents
mycelia Bread mold: sporangiophores spores	Orange-brown Purple-brown Blue
Some carbonaceous debris	Black

TABLE XI

Filters for Photomicrographic Color Balance

Background (clear area) color in transparency	KODAK Color Compensating Filters for adjustment
Blue	Red or magenta*
Purple	Cyan-2* plus red
Green	Cyan* or green
Brown	Cyan-2*

*The No. 12 yellow filter offsets the blue transmitted by these filters.

PHOTOMACROGRAPHY

Photomacrography extends many of the applications discussed under photomicrography. It is accomplished with a simple microscope—one with an objective lens but no eyepiece. Photomacrographic units that are equipped with special lenses and lamps are available from optical manufacturers. Such equipment is best for photographing very small objects at magnifications over ×5. The units are provided with a specimen stage, and also with condensers for transmission photography. Alternatively, a camera lens of short focal length can be utilized in conjunction with a bellows of relatively long extension to provide an adequate setup for low magnifications and occasional work.

The following formula relates the bellows draw (lens-film distance) "v," available on the camera used, to the camera magnification "m" possible with a lens of given focal length "F":

$$v = (m + 1) F$$

Some lenses may perform best in photomacrography when they are mounted backwards on the camera. This can be determined by trial.

A rough rule is useful in photomacrography; the longest dimension of the specimen should not be greater than 2/3 the focal length of the lens. Another manipulative recommendation is: Focusing should be done either by moving the entire camera or by moving the specimen—once the bellows draw has been set for the desired magnification, the position of the lens should not be changed relative to the film plane. Methods of making correction for infrared focus have been presented under "Lenses," on page 20.

When exposure meter readings are made from the specimen an exposure adjustment must be included to allow for the magnification. The exposure calculated from the meter is multiplied by $(m + 1)^2$.

Infrared photomacrography often involves large tissue sections. The infrared-reflection photomacrograph shown in Figure 39 was photographed at ×3 by supporting the slide-mounted tooth section 1 inch above a sheet of black paper. The specimen was lighted by a spotlight on each side at 45 degrees. Infrared filters were placed over the spotlights after the subject was focused. Such an arrangement furnishes good illumination for infrared-reflection photomacrography of flat surfaces. When the specimen is unmounted, and is uneven or rough, a cylinder of translucent white paper can be placed around it vertically; the enclosure is then illuminated from the outside by the spotlights. In this way, obscuring shadows can be avoided. Since the lens is quite close to the subject in photomacrography, the photographer may not notice that illumination could be striking the lens. A lens hood or improvised shield should be used to preclude this.

Transirradiation

The somewhat lengthy exposures required for transmission photomacrography would be perturbed by too much extraneous light, so that some light sources may have to be partly enclosed. Dim light in the room, from the exposing source or elsewhere, is usually tolerable. When apparatus especially designed for photomacrography is utilized, it is usually only necessary to turn off the room lights.

In an improvised setup, the specimen can be supported for transirradiation on flashed opal glass over a 45-degree mirror. A spotlight is then directed onto the mirror to transilluminate the subject. An infrared filter can be placed over the light if the lamphouse is well baffled for stray light. As an alternative, a reflector photoflood bulb can be placed directly under the supporting glass, at about 2 feet below it. The lamp must be in a box, or otherwise enclosed, all the way to the specimen support in order to eliminate stray light in the room. Heat should be guarded against. In such an arrangement, it is more convenient to place the infrared filter over the lens.

In all transillumination setups, the background glass should be masked with thick card stock, arranged as close as possible to the specimen. In fact, with somewhat dense subjects it is necessary to cut a hole in such a card and fit it tightly around the specimen. Then, trouble from flare can be avoided. The amber bead shown in Figure 32 was photographed in this way.

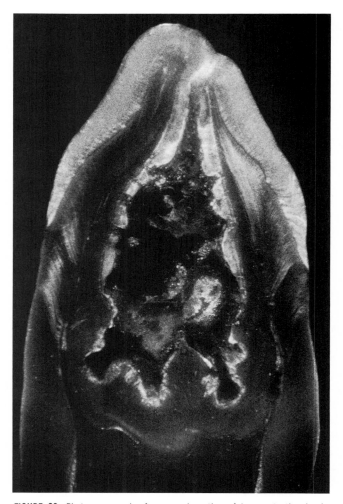

FIGURE 39—Photomacrograph of a ground section of human tooth, showing dens-in-dente. This infrared record was made by the reflection technique.

PHOTOGRAPHING INFRARED LUMINESCENCE

The visible-light fluorescence and phosphorescence excited by ultraviolet radiation is well known. Infrared luminescence, because it occurs in an invisible region of the spectrum, is not so familiar. It can be detected photographically, however.

Probably the first mention of the detection of infrared luminescence was in paper by Dhéré and Biermacher (1936). They reported a spectroscopic study in which a fluorescence (excited by ultraviolet and blue) at 830 nm was found from living geranium leaves and from chlorophylls *a* and *b*. Since their work, it has been discovered that botanical luminescence can be excited by blue-green light or ultraviolet radiation and photographed in regular cameras.

Lazarev and Erastov (1954) and Zyuskin (1960) reported photographic investigations of altered documents by means of recording infrared luminescence excited by ultraviolet. (Other workers have utilized only blue-green light.) The paper by Barnes (1958) on the snooperscope examination of minerals prompted Gibson (1962) to investigate the photography of infrared luminescence in the fields of botany, biology, and medicine.

The early work was done by filtering the illumination through water cells containing copper sulfate solution; Gibson introduced a more convenient and efficient, blue-green glass infrared-absorbing filter. A wide range of subjects can be investigated with the technique. Simple, practical setups can be employed.

Botanical Luminescence

It has long been appreciated that chlorophyll fluoresces in the red and infrared, but phosphorescence remains unproved. Gibson (1963a), however, showed photographically that any phosphorescence that might be present in 1 second is less than 2 percent of the actinic fluorescent emission induced by an 0.1-millisecond pulse of blue-green light. Such luminescence had been thought to account for the light tones of leaves in infrared-reflection photographs.

For experiments in photographing the luminescence of chlorophyll, Gibson (1962) adopted a small piece of greenockite (Hanover District, Grant County, New Mexico) as a control. This was selected because Barnes (1958) had determined that, while the infrared luminescence characteristics of most minerals were erratic, depended upon impurities, and varied with the source locality, one mineral—greenockite, cadmium sulphide—consistently fluoresced.

Figure 40 shows how specimens can be arranged for comparing luminescence characteristics and demonstrates how results can be evaluated. It can be seen that components with no chlorophyll did not luminesce. For instance, the flower petals below the maple leaf are devoid of exposure. However, the upper petals transmitted infrared emitted by the maple leaf behind them. There is also lateral scatter in the bract, which prevents the white margin from appearing very dark, although it is still a little darker than the green part. It is obvious that such scatter, or transmission, must be taken into account when the luminescent qualities of specific specimens are being studied. This is true also of any reflected glow from an adjacent area. In this connection it should be pointed out that when the rock bearing the native cadmium sulphide was broken up, a piece was selected that presented the yellow mineral only toward the camera—the other exposed faces were all of dark nonemissive rock.

The blackness of the ring of chaff on the rush was caused by its absorption of the blue-green excitation

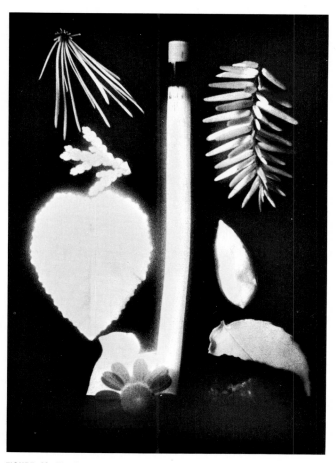

FIGURE 40—The botanical specimens were arranged for studying the infrared reflection of plant tissues and the infrared luminescence of chlorophyll, as described on page 13. Compare this infrared-emission photograph with the panchromatic and infrared-reflection renditions shown in Figure 9.

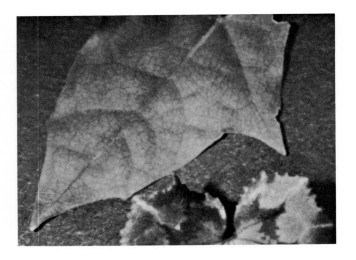

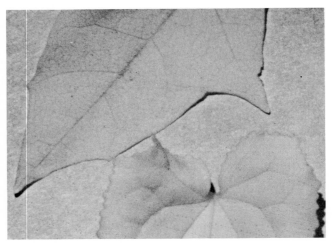

FIGURE 41—This comparison demonstrates that chlorophyll does not reflect infrared and that leaf tissue does not emit infrared. **Top:** Panchromatic record; **center:** infrared reflection; **bottom:** infrared luminescence. In the bottom photo notice that the cement used for attaching the leaf to the background had leached out the chlorophyll, which formed a concentrated ring around the depleted area. The other two photographs show that the leaf tissue had not been affected.

light; this was thereby prevented from reaching the chlorophyll below. It is also interesting to note that the sclerophyllic leaves here did not luminesce as brightly as the softer ones. The same test object was photographed after two months of drying in the laboratory, with similar results. Dried extracted chlorophylls also luminesced.

In other experiments it was found that the yellowing pigments in the stems of *Equisetum arvense* did not luminesce like those of *E. hymenale*. However, the green foliage of *E. arvense* did. The solvent in the rubber cement used to affix the maple leaf of Figure 41 leached the chlorophyll from parts of the leaf. These depleted areas did not luminesce, although the tissues did reflect infrared—no disturbance can be seen in either the panchromatic or infrared-reflection records.

Gibson (1936a and 1963b) devised a method for photographing and calculating the degree of infrared phosphorescence in substances exhibiting an appreciable persistence. He also discovered a reversible fatigue effect in the infrared fluorescence of chlorophyll in the leaves of a living plant. Garnier (1967) discovered, and recorded by photographing infrared luminescence, certain anomalies in the mechanism of photosynthesis exhibited by several colonies of green algae, *Chlamydomonas reinhardi*. Under specific conditions the colonies exhibited an enhanced fluorescence in the infrared when excited by wavelengths shorter than 600 nm.

Fossil and Insect Luminescence

The fossil shown in Figure 42 was transparent to infrared but luminesced strongly. Because of the wellknown infrared transparency of chitin, some authorities believed the fossil might be a compressed exoskeleton. However, experiments showed no luminescence from several of our contemporary insect and crustacean specimens. This suggests a mineral replica and also points to a nondestructive method of testing.

It was also discovered that some fossil matrices and the aged surface of an oil shale luminesced. (See Figure 43.) Tar-pit matrix, however, did not.

Luminescence of Wood Resins and Coal

When the hemlock knot of Figure 2 luminesced, the glow was the brightest in the dense centre. Plastic wood, used to repair cracks in the knot, reflected infrared relatively stronger than it emitted infrared. A cloudy Baltic amber bead luminesced strongly, suggesting a possible way to detect imitation amber.

Friedel and Gibson (1964) were able to distinguish coal samples by infrared reflectance and luminescence. (See Figure 44.) Table XII indicates their early find-

FIGURE 42—This fossil crayfish, Eryma leptodactylina, in Jurassic (Solenhofen, Bavaria) limestone matrix, appeared visually to have a dark amber color, probably quite similar to that of the living specimen. The fossil was very transparent to incident infrared and brightly luminescent under blue-green excitation. The small piece of rock was a greenockite specimen used as a "standard" in luminescence experiments.

FIGURE 43—The almost black, weathered surface of this specimen of oil shale (Green River formation, Garfield, Colorado) can be seen at the left, just above the ball bearing; the lighter, freshly broken surface contains an unidentified fossil. **Top:** Visual appearance of the shale; **center:** infrared-reflection record, which has the same relative tone values as the visual appearance; **bottom:** the tones have become reversed in the infrared-emission record because the weathered surface luminesced. Notice that the catchlights in the ball bearing are very tiny in the bottom photograph; this indicates that the blue-green filter was extremely efficient (see text).

ings. Infrared-reflectance characteristics are given to indicate features that help to serve in differentiation.

Luminescence of Biological Substances

Infrared photographic investigations were made with gallstones and other medical specimens (Gibson, 1963a) and with teeth and related tooth substances (Gibson, 1963d). Figure 45 illustrates the method of investigation employed. Table XIII shows the posibilities that exist in this field.

Luminescence of Documents and Artifacts

The early work in the document field has already been discussed. (See page 49.) Later personal communications with workers in the field indicate that the technique of recording such luminescence is proving extremely valuable in law enforcement. For example, it has been found that ball point inks are definitely susceptible to differentiation by the method. This often makes the detection of altered documents easy.

There are likely to be new applications for the technique in archaeology. The luminescence of Dead Sea scroll material has already been described. (See Figure 20.) Since wood, paper, and some minerals luminesce, there may be applications in examining other ancient inscriptions and artifacts. Mitchell (1935) found that the ancient Egyptian pigments—orpiment, ochres, azurite and Egyptian blue—were transparent in the infrared-reflection technique. He was not, of course, able to determine whether they could be emphasized or differentiated by the emission technique.

Bridgman and Gibson (1963) have published a series of experiments made with painters' pigments. Among other characteristic emissivities, they found that those from cadmium pigments were particularly intense. (See Figures 28 and 29.) The photography of infrared luminescence in connection with studying army canteens has been discussed in connection with Figure 30.

Black-and-White Photography

The basic principle involved in photographing infrared luminescence is that of excluding infrared from the excitation radiation and barring visible light from the

TABLE XII

Infrared Luminescence and Reflectance of Coal Samples		
Sample	Infrared Luminescence	Infrared Reflectance
Pittsburg Vitrain	Low	Intense
Pittsburg coal	High	Moderate
Anthracite	None	Intense
Lignite	None	Intense
Asphaltine, solid	High	Moderate
Asphaltine, in benzene	Very High	Low
Graphite	None	Moderate

film. The black-and-white technique is discussed first; some work can be done in color, and this is described subsequently.

Filters: Blue-green filters are needed over the light source and an opaque infrared filter is needed over the camera lens. Any infrared image formed by the camera can then come only from radiation emitted by the subject. The filters listed below can be used; the lamp filters do not have to be optically polished.

FILTERS TO PROVIDE BLUE-GREEN EXCITATION:

9780—Corning glass color filter, C.S. No. 4-76, molded, 8mm (blue-green).*

3966—Corning glass color filter (Aklo type), C.S. No. H.R. 1-59, molded and tempered, 4 mm (heat-absorbing).*

OPAQUE BARRIER FILTER:

No. 87—KODAK WRATTEN Filter No. 87 (infrared).

*Available from Corning Glass Works, Optical Sales Department, Corning, New York 14830.

A 13 percent copper sulfate solution in a water cell can be used in place of the blue-green filters. It is not as efficient and is also rather clumsy, because an absolutely lighttight tunnel has to be built between it and the lamp. The glass filters, on the other hand, can be fitted into photographic spots or into light boxes. They must not leak visible light. The 3966 filter protects the 9780 glass from heat and it must be located between the 9780 glass and the light source.

Setups: The diagram in Figure 47 schematizes the setup and illustrates the difference between infrared reflection, top and infrared-emission, bottom, methods. When spotlights are used, the photography must be done in a completely dark room, and light baffles or heavy fireproof cloth on a wire frame must be used to prevent radiation from leaking out of the ventilators. Should a continued program of luminescence photography be contemplated, especially when

FIGURE 44—These coal specimens were placed in ends taken from 35mm film magazines; pieces of old dense negatives were cemented underneath to hold the powdered samples. These convenient receptacles had low infrared reflection and no infrared luminescence. They served to isolate the specimens so that reflection or emission from any sample would not be picked up by a neighbor. The asphaltine solution in benzene was placed in a small metal crucible. For results of the experiment, see Table XII. The object in the center is the greenockite standard.

ultraviolet photography is also planned, it is much more convenient to build a lighttight box to hold the specimen. This will simplify the lighting problem greatly. Since exposure times become quite lengthy for faint emissions, we have found aluminum, a fully infrared-opaque material, more suitable as a construction material than wood. Figure 48 shows the light-locking details of a specimen box built specifically for luminescence and fluorescence photography. The glass filters (for ultraviolet or infrared photography) must be fitted so as to be lighttight. Also, they must not be held so tightly that they crack when hot. The box is primarily intended for specimens, but it could be modified for investigating sections of paintings. For that purpose, the bottom could be made removable from the box so that the rest of the box could be placed on the painting. The inset shows an angle frame that would make the bottom of the modified box lighttight.

Kirchgessner (see Figure 46) has worked out an extremely simple technique for specialized luminescence photography in his darkroom. He made a pair of lighting units, each comprising a 1/2-inch plywood enclosure for six General Electric F-6, T5-W fluorescent tubes. The windows are 6-1/4-inch squares of Corning 9788 glass. The tubes burn cool enough to obviate the need for heat-absorbing glass. With KODAK High Speed Infrared Film, his average exposure time was 45 seconds at $f/5.6$ when the lights are 15 inches from the subject. This 9788 filter glass appears to be well suited to the investigation of questioned documents. However, for most specimen work, the 9780 filter glass provides a purer source of blue-green light.

Exposures: KODAK High Speed Infrared Films have proven to be quite valuable in the infrared-luminescence technique. Although exposure times can only be roughly approximated and then a trial exposure made, reciprocity failure must be taken into consideration

FIGURE 45—Infrared reflection (top) and luminescence (bottom) of biological specimens. Differences are readily observed. Of particular interest are the thyroid nodule, the adrenal tissue, and the arteries.

Key: from upper row, left to right: vertebral bone, impacted teeth, atherosclerotic aorta (intimal surface), (object identified); spleen, thyroid, adrenal, and kidney tissues; atherosclerotic coronary artery, aorta (external surface), myocardium, and coronary artery.

TABLE XIII

Infrared Luminescence of Biological Substances		
Substance	Infrared Luminescence	Infrared Reflection
Physiological:		
Healthy skin	Strong	Strong
Healthy blood (human) *in vitro*	None	Weak
Bone, cortical, old;	Moderate	Strong
cancellous, old;	Moderate	Strong
cortical, fresh;	Weak	Moderate
cancellous, fresh	Trace	Moderate
Tooth, old	Strong	Moderate
Artery, wall;	Weak	Weak
lining	Strong	Weak
Adrenal medulla;	Trace	Moderate
cortex	Strong	Moderate
Aorta, lining	Moderate	Moderate
Spleen	Moderate	Weak
Kidney	None	Moderate
Thyroid; myocardium	None	Weak
Biochemical:		
Chlorophyll	Very Strong	None
Some yellow plant pigments	None	?
Leaf tissue	None	Strong
Bilirubin powder	Strong	Moderate
Biliverdin powder	None	Trace
Cholesterol	Trace	Strong
Thiamine	Trace	Strong
Uric acid	Trace	Strong
Mineral:		
Hydroxyapatite, crystal	None	Moderate
Chalk (Dover)	Moderate	Strong
Calcium phosphate	Trace	Strong

* Available from Corning Glass Works, Optical Sales Department, Corning, New York 14830.

when new exposure times are calculated from test negatives.

An exposure meter and the gray side of a KODAK Neutral Test Card can be used in ascertaining exposures. A reading should be made under the blue-green illumination. This reading should then be treated as a tungsten reading. The exposure that would be given an ordinary infrared-reflection record, under such an intensity and with the film being used, should be calculated. The dummy exposure time so obtained must then be multiplied by 20,000 to yield the real exposure for the infrared-emission photograph when high-speed film is employed.

Luminescence exposures are about 6 minutes at f/5.6, with two 500-watt spotlights at 3 feet and with KODAK High-Speed Infrared film.

A KODATRON Speedlamp, with a power output of 225 watt-seconds, was used successfully to determine whether luminescence from a living subject could be photographed. (This unit is no longer available, but similar equipment can be obtained from various manufacturers.) The lamp reflector was removed and the envelope of the flashtube partially wrapped in aluminum foil to make it lighttight, except on one end. Then a blue-green filter was taped at the open end. With this filter 3 inches from the subject, a single flash (1/10,000 second) served to expose high-speed infrared film at a lens opening of f/2.8. Such a fast flash would not be needed in further work.

The setup shown in Figure 13 was fitted with the blue-green glass filters and the lamps dropped to about lens level. A KODAK WRATTEN Filter No. 87 was placed over the camera lens. Utilizing the full power (200 watt-seconds from each unit), it was found that a good luminescence exposure could be obtained at f/5.6, with

KODAK High Speed Infrared Film 2481 (ESTAR Base). Green leaves formed the subject. Dim ambient light was present. The lamp-subject distance was 15 inches. Other subjects, such as documents and animal tissues or lesions, could be photographed with such a hand-held set when convenient. Luminescence that is 1/4 as bright as that from leaves could be recorded at f/2.8. Weaker emissions would necessitate other techniques involving more powerful light units. Since there is the need for an opaque filter over the lens, a single-lens reflex camera should be equipped with a supplementary view and range finder for handheld operation of the unit shown in Figure 13.

Because of the ease with which electronic flash lamps can be fitted with filter windows, it is practical to photograph inanimate subjects with several flashes, provided the setup were not jarred. Such a setup would not present the heat and stray-light problems encountered with tungsten lamps.

Checking Setups: Any setup for photographing infrared luminescence should be tested by photographing a subject of sure emission—a tooth, bilirubin powder, or a green leaf can be employed. Another factor to check in the setup is the purity of the excitation. If even a small amount of radiation leaks around the filter or out of the lamp enclosures it can cause a false rendition, because of the long exposures involved. A shiny ball bearing should be placed alongside the specimen. (See Figure 43.) It will pick up only faint, small infrared catchlights from the blue-green illumination, since only a very minute amount of infrared is passed by the excitation filters. Should bright, large, or multiple catchlights occur in the photograph, these would indicate that infrared radiation is coming from somewhere else in the setup, or through a cracked or very loosely fitted filter.

FIGURE 46—The panchromatic copy of this forged check (left), as well as other photographic tests, showed "Robert" as the christian name. The infrared-luminescence record, however, clearly revealed an alteration. Note that the **"Le"** of the original name had been changed to an **"R"**; that the **"o"** had not been tampered with; and that the rest of the name had been bleached out and written over. (Courtesy of W. G. Kirchgessner, Monroe County Public Safety Laboratory, Rochester, New York.)

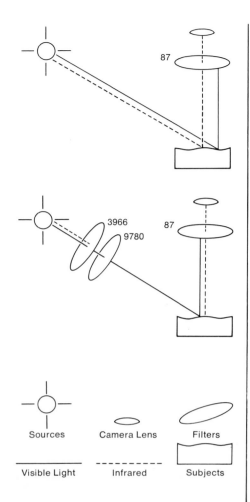

Sources Camera Lens Filters

Visible Light Infrared Subjects

FIGURE 47—Diagram illustrating the basic difference in setups for infrared-reflection (top) and infrared-luminescence (bottom) photography.

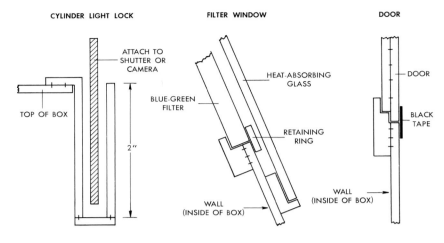

CYLINDER LIGHT LOCK

ATTACH TO SHUTTER OR CAMERA

TOP OF BOX

2″

FILTER WINDOW

HEAT-ABSORBING GLASS

BLUE-GREEN FILTER

RETAINING RING

WALL (INSIDE OF BOX)

WALL (INSIDE OF BOX)

DOOR

BLACK TAPE

REMOVABLE BASE

SIDE WALL OF BOX

BLACK CLOTH

ANGLE IRON 1″ x ¾″

⅛″ BLACK FOAM RUBBER

FIGURE 48—An aluminum irradiation box with windows on each side conveniently serves for infrared luminescence photography as well as fluorescence photography. Since the bellows was found to leak infrared, it was wrapped in heavy-duty aluminum foil. The design and dimensions of the box depend on the application and camera to be used (photomacrography in this case). The important features of light locking are given in the sketches. Light locking steps are sprayed with heat-resistant matte lacquer containing carbon pigment. Additional protection around the door can be provided with black Scotch photographic tape, 235. The rest of the aluminum can be left unfinished. The ground edges of the filters can be wrapped with thin, black, pressure-sensitive tape in order to reduce light leak into the box. Filter clearance is 1/64 inch all around. Heat-absorbing glass is needed in the infrared luminescence technique for reducing heat to the glass filter. The removable base allows areas of large paintings or other flat specimens to be photographed by the luminescence technique.

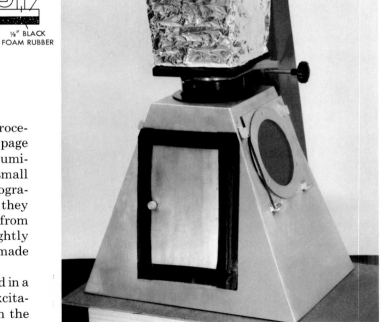

Photomacrography, Photomicrography: The procedures for making photomacrographs described on page 69 can be followed for recording the infrared luminescence of small specimens. Spotlights with small beams or the focusing lamps used in photomicrography are useful for lighting small areas. However, they must be enclosed or baffled to prevent stray light from escaping. The blue-green filters should be fitted tightly enough to eliminate light leaks. Figure 49 was made with two baffled spotlights.

Infrared luminescence can also be photographed in a photomicrographic setup (Gibson, 1963d). The excitation filters are placed in the light patch between the lamp and the substage condenser. The infrared filter (No. 87) is located at the eyepiece.

As a sample exposure, found for sectioned human dentin, the following factors were involved: × 90, N.A. 0.35, Kohler illumination—15 minutes with the high-speed infrared film.

Figure 50 depicts an infrared-luminescence photomicrograph of a specimen photographed by this technique. It was discovered that a beam splitter could not be used. The exposures were so long that the eyepiece of this device focused an image of the dim room onto the film.

Infrared Color Photography

Infrared color film was investigated as a medium for photographing deep-red fluorescence, (excited by ultraviolet-blue) and infrared luminescence (excited by blue-green).

Fluorescence: The visible and strong near-infrared fluorescence of several substances under blue plus ultraviolet was photographed by Gibson, *et al* (1965). The exciting illumination was obtained from two 500-watt spotlights. A KODAK WRATTEN Filter No. 34 (violet), which cuts at about 500 nm, eliminated green. To remove red and infrared, Corning glass color filters C.S. No. 1-59 (3966) and C.S. No. 4-76 (9780) were also placed over the spotlights. The usual No. 12 filter served as a barrier filter at the camera. However, since it transmits some ultraviolet and also fluoresces under ultraviolet radiation, a KODAK WRATTEN Filter No. 2E (straw-colored) was placed over it. A color-compensating filter CC20M was also employed to tentatively offset departure from the reciprocity law.

Color Plate II illustrates several of the modified colors obtained. Human tooth enamel, cementum, and bone—which fluoresce strongly in the near infrared and weakly in the red—were recorded green-gray by the technique. In contrast, those specimens which do not fluoresce in the red—biliverdin in serum, cholesterol, chalk, and apatite—photographed blue-gray. A green leaf, the top of a shell, and bilirubin powder recorded greenish as a result of some strong visible red emission. Biliverdin powder recorded black because of a lack of fluorescence. It is likely that the technique could be useful in studying the composition and stratification of gallstones and other physiological accretions. The exposure is about a quarter of that required for the luminescence technique now to be described.

Luminescence: Infrared luminescence can be photographed with infrared color film. With the two 500-watt spotlights discussed previously (without the No. 34 filter), and with a KODAK WRATTEN Filter No. 88A (infrared) over the camera lens, the exposure was 20 times that needed for KODAK High Speed Infrared Film; that is, 30 minutes at f/2.8. Of course, the results were a monochromatic red because only the infrared-sensitive layer was affected. Yet areas that emit infrared luminescence were clearly delineated. Thus

FIGURE 49—These photomacrographs, at X3, were made from a fresh, frozen, 100 nm section of an artery wall of a blue shark, *Prionace glauca*. The section was difficult to handle, and the intima rolled outward as it was mounted on a glass slide. In the luminescence record (top), an internal layer emitted more strongly than the rest of the artery wall. This layer did not appear in the panchromatic photograph (bottom), nor in other infrared-reflection and ultraviolet-fluorescence experiments. Standard pathological examination at higher magnifications gave evidence of early atherosclerosis in the artery. (Specimen courtesy of Professor Albert I. Lansing, University of Pittsburgh.)

the color material would be useful for an occasional record.

Reciprocity: In both of the above techniques, reciprocity* is a factor. The exposure times are so long, however, that it is not practical to relate the degree of departure from the reciprocity law to the speed of the film under the electronic flash illumination ordinarily adopted. At longer exposure times, the speed of the infrared-sensitive layer is reduced and the results go cyan (in the photography of fluorescence). Experiments with magenta and blue filters on the camera, and with exposure times, are therefore necessary for arriving at a reasonably representative color differentiation. For the luminescence technique, reciprocity merely affects exposure time, because the actual color of the record is unimportant; the correct exposure time can be determined by means of a series of tests.

TECHNICAL APPLICATIONS

Industrial and Commercial Uses

Clark (1946) describes the clarity with which pore sites in rusted tin plate can be mapped through the rust surface by means of black-and-white infrared photography. He also gives references on using the technique

*The reciprocity law states that for a given exposure (which is radiation intensity multiplied by the exposure time), an emulsion yields the same density regardless of the length of the exposure time. Most emulsions depart to some extent from this law when exposure times become very short or very long. This results in appreciable speed changes in some black-and-white and color films, and color changes in the latter. When necessary, adjustment factors are stated in the data provided by film manufacturers.

in the detection of carbonaceous matter in lubricating oils, the inspection of welds, and the study of reduction arcs. Besides this, his book contains sections and bibliographies on the uses of infrared photography and photomicrography in the textile industry.

Photoengravers in the graphic arts industry have used infrared-sensitive plates to differentiate between light and dark blues in multicolor printing and in preparing the negative of the black printing plate from originals prepared in specially selected colors. Wallis (1952) describes one such technique.

Photography of Hot, Calorific, and Warm Subjects

Infrared-sensitive materials are valuable for studying the temperature distribution of hot bodies that are just below red heat—such as stoves, engine parts, high-pressure boilers, electrically heated appliances, cooling ingots and castings, and insulation coverings. Figure 51 demonstrates the actinic property of hot flat irons in providing infrared radiation for reflection photography. The range of temperatures which can be recorded, or used for irradiation is from about 250° to 500°C (482° to 932°F). Below this temperature range, the radiation is nonactinic; above it, some of the radiation is in the visible region.

On a single exposure it is possible to record temperatures within a 150 Celsius-degree (270 Fahrenheit-degree) range. If an object's temperatures exceed this range, two or more negatives will be needed. A long exposure time will record the cooler parts and a short exposure, the hotter parts. Such direct photographs of the hot object itself depict the full extent of the heat pattern, provided the radiation is within the actinic range. The actual exposures will have to be determined

FIGURE 50—Comparison between photomicrographs made by the infrared-emission (left) and infrared-transmission (right) techniques. The specimen is a sectioned human tooth photographed at X90. Dentin possesses marked structural variations in density to infrared transmission, yet the emission intensities are quite homogeneous.

by experiments, since they can vary from 4 minutes at $f/5.6$—with hot objects (275 to 350°C) and KODAK High Speed Infrared Films—to several minutes, or even hours, with slightly cooler objects. An exposure series made by doubling successive exposure times will usually serve to locate the proper exposure level.

Photography of hot objects must be done in a completely darkened room; otherwise, the photograph is obtained by reflected, not radiated, infrared. If a small amount of stray light is unavoidable, a satisfactory record can be obtained if the camera's lens is covered with a KODAK WRATTEN Filter No. 25 or 87 to avoid exposure by the blue component of the stray light. No filter is needed if total darkness is possible. Precautions should be taken to prevent the surroundings from burning if the object is to be heated for a long exposure. For related information see **Electronic Thermography,** page 5. Hamlin (1968) presents radiation curves for temperatures ranging from 90 to 620°F and discusses the use of an infrared electonic thermometer.

Chemical reactions taking place in various regions of flames also can be studied by comparing panchromatic and infrared renditions. Beral (1949) reviews many applications and gives a bibliography in the field.

Nonactinic radiation can only be recorded by indirect methods—see page 5. Technical literature should be consulted for manufacturers of such heat cameras.

Howard (1963) discusses a technique involving paint-like preparations, available commercially, which will change color when heated to a specific temperature. These color changes are normally irreversible, and individual preparations may exhibit as many as four different changes at successive temperatures. By applying one of these substances to a calorific body, it is possible to produce on its surfaces a visible representation of the temperature distribution. This representation may be photographed in color or monochrome when a record is required.

Woodmansee (1966) describes the use of cholesteric liquid crystals in photographing heat patterns in warm subjects. These include those patterns caused by interruptions of heat flow by fine cracks in airplane wings, and by poor bonds in aluminum panels, or heat patterns produced by overheating in microcircuits.

The human body is within the warm-object range. Thermographic methods of recording its heat patterns in pathological conditions and references to the field are given on page 5. Strandness (1967) shows several illustrations of color patterns produced in liquid crystals by the body.

FIGURE 51—Infrared-reflection photograph made in the dark solely by means of the hot-object emission from the flat irons shown. No filter was used over the lens. For this type of photography, exposures have to be determined by trial. For two 750-watt flat irons at about 18 inches, and with KODAK High Speed Infrared Film 4143, an exposure of 10 minutes at $f/5.6$ should be tried. The infrared reflectance of the subjects will have a bearing on the negative density obtained.

REFERENCES

Andreucci, E. 1964. The behaviour of vegetation in infrared photography. **Ferrania, 12,** 13-19.

Anon. 1963. Infra-red microscope. **Med. Biol. Ill., 12,** 193.

Anon. 1966. Good subject, good idea. **Pop. Photogr., 59,** No. 6, 102-111.

Beaver, B. and Wood, J. 1973. Aerial Infrared Locates Solid Ground Over Mine. **Civil Eng.,** March, 1973, 62-3.

Barnes, D. F. 1958. Infra-red luminescence of minerals. **Geol. Survey Bul., 1052-C.** Washington: United States Government Printing Office (visual study only).

Barnes, R. B. 1963. Thermography of the human body. **Science, 140,** 870-877.

Bawden, F. C. 1933. Infra-red photography and plant virus diseases. **Nature, 132,** 168.

Beardsley, N.F. 1936. The photography of altered and faded manuscripts. **Library J., 61,** 96-99.

Bendikson, L. 1932. Phototechnical problems: some results obtained at the Huntington Library. **Library J., 57,** 789-794.

Bendikson, L. 1933. Charred documents. **Library J., 58,** 243-244.

Beral, L. 1949. Photographic techniques in combustion research. **Phot. J., 89B,** 98-107.

Blair, D. M., and Davies, F. 1933. Infra-red plates in neuro-histological illustration. **Lancet, 225,** II, 801.

Bridgman, C. F., and Gibson, H. L. 1963. Infra-red luminescence in the photographic examination of paintings and other art objects. **Studies in Conservation, 8,** 77-83.

Broughton, R. 1971. Corn Blight Watch. **Corn Blight Information Center,** Washington, D.C. (Agriculture)

Cade, C. M. 1962. Unlimited scope for infra-red photo surveys. **Can. Ind. Photo.,** 33-35, Oct.

Cade, C. M. 1964. The industrial potential of the "heat camera." **New Scientist No. 400,** 165-167, J1.

Cartwright, H. C. 1930. Infra-red transmission of the flesh. **J. Opt. Soc. Am., 20,** 81-84.

Casida, L. E., Jr. 1968. Infrared color photography: selective demonstration of bacteria. **Science, 159,** 199-200.

Ciesla, W. M., Bell, J. C. Jr., and Curlin, J. W. 1967. Color photos and the southern pine beetle. **Photogram. Eng., 33,** 882-888.

Ciesla, W. M., et al. 1971. Color Photos, Aerial Sprays and the Forest Tent Caterpillar. **Photogram. Eng., 37,** 867-873. (Aerial Photography, Forestry)

Clark, W. 1941. Atmospheric haze. **Photo Technique, 3,** 50-55.

Clark, W. 1946. **Photography by infrared,** 2nd ed., New York: John Wiley and Sons, Inc. See also Gibson (1978).

Colwell, R. N. 1956. Determining the prevalence of certain cereal crop diseases by means of aerial photography. **Hilgardia (Cal. Agric. Exp. Sta.), 26,** No. 5.

Colwell, R. N. 1964. Aerial photography—a valuable sensor for the scientist. **Am. Scientist, 52,** 16-49.

Colwell, R. N. 1967. Remote sensing as a means of determining ecological conditions. **BioScience, 17,** 444-449, and cover.

Colwell, R. N. 1968. Remote sensing of natural resources. **Sci. Am., 218,** 54-69.

Colwell, R. N., Estes, J. E., Tiedeman, C. E., and Fleming, J. E. 1966. The usefulness of thermal infrared and related imagery in the evaluation of agricultural resources. **Report of the University of California, 1 & 11.** No. 12-14-100-8316(20).

Coremans, P. 1938. Les rayons infra-rouges; leur nature; leurs applications dans les musées. **Bulle. Musées Royaux Art Hist., 6,** 87-91.

Cott, H. B. 1956. **Zoological photography in practice.** London: Fountain Press.

de Latil, P. 1961. Color photography as an instrument of scientific observation and measurement (with technical data by I. Kitrosser). **Camera (Lucerne), 40,** 29-56.

Dent, R. V. 1941. The photographic aspect of light reflection from human skin. **J. Lab. Clin. Med., 26,** 1852-62.

Dhéré, C., and Biermacher, O. 1936. Spectrochimie biologique. **Compt. Rend., 203,** 412-414.

Drechsel, L. 1958. Ultrarot Polarisationsfilter. **Jenaer Jahrbuch, 1,** 55.

Emerson, H. J. 1941. Stamp forger beware! **Photo Technique, 3,** 42-45.

Engel, C. E. 1959. Modern developments in infra-red recording. **Discovery, 20,** 392-396.

Engel, C. E. 1961. Infrared rays and their application. In: **Medical photography in practice,** (London: Foutain Press) 137-174.

Engel, C. E., Ed. 1968. **Photography for the Scientist.** London and New York: Academic Press.

Facto, L. A., and Catron, D. V. 1961. Time lapse cinematography as a method of studying animal behaviour and ration preferences. **J. Biol. Phot. Assoc., 29,** 113-123.

Farnsworth, M. 1938. Infra-red absorption of paint materials. **Technical Studies, 2,** 88-98 (Fogg Museum of Art).

Fielding, R. 1965. **The technique of special-effects cinematography.** New York: Hastings House.

Fowler, F. W., Jr., and Harlow, W. M. 1940. Infra-red photomicrography reveals plant cell-wall structure. **Paper Ind. Paper World, 21,** 1159-60.

Fremlin, J. H., and Srirath, S. 1964. Thermo-luminescent dating; examples of non-uniformity of luminescence. **Archaeometry, 7,** 58-62.

Fricke, W., and Völger, K. 1965. Falschfarben--photographie für die Luftbild-interpretation. **Umschau Wiss. Tech., 65,** 441-442.

Friedel, R. A., and Gibson, H. L. 1964. Infra-red and ultra-violet visible spectrometry. **Internal Report U. S. Dept. of Interior, Bureau of Mines, 30,** J1.

Fritz, N. L. 1965. Film sees new world of color. **Citrus World, 2,** No. 2, 11-12, 26.

Fritz, N. L. 1967. Optimum methods for using infrared-sensitive color film. **Photogram. Eng., 33,** 1128-38.

Fritz, N. L. 1977. Filters: An Aid in Color-Infrared Photography. **Photogram. Eng., 43,** No. 1, 67-72.

Fugate, J. M. 1954. A masking technique for isolating the pupillary response to focused light. **J. Opt. Soc. Am., 44,** 771-779.

Garnier, J. 1967. Une méthode de détection, par photographie, de souches d-algues vertes émettant **in vivo** une fluorescence anormale. **Compt. Rend., 265,** 874-877.

Gates, D. M., and Tantraporn, W. 1952. The reflectivity of deciduous trees and herbaceous plants to the infra-red to 25 microns. **Science, 115,** 613-616.

Gelatt, D. S. 1967. So, rent a helicopter. **Pop. Phot., 60,** No. 2, 94-99.

Gibson, H. L. 1948. Notes on the equilibrium of tropical aquarium fishes and their perception of colour. **Proc. Rochester Acad. Sci., 9,** 139-140.

Gibson, H. L. 1962. The photography of infra-red luminescence, Part I. **Med. Biol. Ill., 12,** 155-166.

Gibson, H. L. 1963a. The photography of infra-red luminescence, Part II. **Med. Biol. Ill., 13,** 18-26.

Gibson, H. L. 1963b. The photography of infra-red luminescence, Part III. **Med. Biol. Ill., 13,** 89-90.

Gibson, H. L. 1963c. Infra-red color translations. **Dent. Radiogr. Phot., 36,** 33, and outside cover.

Gibson, H. L. 1963d. Photographing ultraviolet and infrared luminescence. **Dent. Radiogr. Phot., 36,** 34-39.

Gibson, H. L. 1964. Diffuse lighting for clinical infrared photography. **Med. Radiogr. Phot., 40,** 38-40.

Gibson, H. L. 1965. Further data on the use of infra-red color film. **J. Biol. Phot. Assoc., 33,** 155-156.

Gibson, H. L. 1966. A white cubicle for diffuse illumination in infra-red and general biological photography. **J. Biol. Phot. Assoc., 34,** 23-28.

Gibson, H. L. 1967. Strong infra-red absorption by rotted cactus pulp. **J. Biol. Phot. Assoc., 35,** 120-125.

Gibson, H. L. 1971. Multi-Spectrum Investigation of Prehistoric Teeth. **Dent. Radiogr. Phot., 44,** 57-65. (*Archeology, Art, Museum Artifacts, Infra-red Luminescence*)

Gibson, H. L. 1978. **Photography by infrared,** 3rd ed., New York: John Wiley and Sons, Inc.

Gibson, H. L., Buckley, W. R., and Whitmore, K. E. 1965. New vistas in infra-red photography. **J. Biol. Phot. Assoc., 33,** 1-33.

Glazier, R. M., and Fernelius, A. L. 1967. Agar gel staining technique for improved contrast of precipitin line photography. **J. Biol. Phot. Assoc., 35,** 3-10.

Gosling, J. W. 1962. Photographic separation of colored imprints by masking techniques. **Identification News, 12,** 4-10.

Greenhill, L. P. 1955. The recording of audience reactions by infra-red photography. **Technical Report—SPECDEVCEN, 269,** 7-56. For Special Devices Center, United States Government.

Greenhill, L. P. 1962. The use of infra-red-memomotion photography in research on human behaviour. **Forschungsfilm, 4,** No. 4, 349-352.

Griffin, D. R. 1958. **Listening in the dark.** New Haven: Yale University Press.

Haack, P. M. 1962. Evaluating color, infrared and panchromatic aerial photos for the forest survey of interior Alaska. **Photogram. Eng., 28,** 592-598.

Hackforth, H. L. 1960. **Infrared radiation.** New York: McGraw-Hill.

Hamlin, W. O. 1968. Infrared temperature measurements. **Electronics World,** 34-36.

Hardy, J. D., and Muschenheim, C. 1936, Radiation of heat from the human body—V; the transmission of infra-red radiation through skin. **J. Clin. Investigation, 15,** 1-9.

Harris, J. E., and Latham, E. 1951. Infra-red photography of fossils. **Med. Biol. Ill., 1,** 130-135.

Harrison, G. R., Lord, R. C., and Loofbourow, J. R. 1949. **Practical spectroscopy, 2nd printing,** Chap. 17. New York: Prentice-Hall, Inc.

Harrison, W. R. 1958. **Suspect documents.** London: Sweet and Maxwell, Ltd.

Harwood, T. A. 1966. Infrared imagery in the arctic under daylight conditions. **Proc. 4th Sympos. on Remote Sensing of Environment, 12, 13, 14,** 231-241.

Heller, R. C., *et al.* 1966. The use of multispectral sensing techniques to detect ponderosa pine trees under stress from insect or pathogenic organisms. **Annual Progress Report, Pacific Southwest Forest and Range Experiment Station, U. S. Dept. of Agriculture.**

Herman, A. L., and Leinbach, H. 1951. A photographic study of changes of the infrared emission of the polar aurora. **Trans. Am. Geophysical Union, 32,** 679-82.

Hess, E. H. 1965. Attitude and pupil size. **Sci. Amer., 212,** 46-54.

Hirsch, E. S. 1975. Infrared Photography and Archaeology— Painted Floors at Gournia. **Archaeology, 28,** No. 4, 260-266.

Holter, M. R. 1967. Infrared and multispectral sensing. **Bio-Science, 17,** 376-383.

Holter, M. R. Nudelman, S., Suits, G. H., Wolfe, W. L., and Zissis, G. J. 1962. **Fundamentals of infrared technology.** New York, London: MacMillan Co.

Hours-Miedan, M. 1957. **A la découverte de la peinture par les méthodes physiques.** Paris: Arts et Metiers Graphiques.

Howard, D. R. 1963. A photographic technique for the measurement of transient high temperatures. **Engineer, 215,** 474-475.

Hultzén, G. 1934. Det infrarödkänsliga materialets användning vid reproductionsarbetet. **Nord. Tid. Fot., 18,** 170-172.

Hunter, G. I., and Bird, S. J. Glenn. 1970. Critical Terrain Analysis. **Photogram. Eng., 36,** 939-952. (*Aerial Photography, Geology, Photography*)

Ives, R. L. 1939. Infra-red photography as an aid in ecological surveys. **Ecology, 20,** 432-439.

Jackson, R. 1964. Detection of plant disease symptoms by infrared. **J. Biol. Phot. Assoc., 32,** 45-58.

Jackson, H. R., et al. 1971. Potato Late Blight Intensity Levels as Determined by Microdensitometer Studies of False-Color Aerial Photographs. **J. Biol. Phot. Assoc., 39,** 101-106. (*Aerial Photography, Agriculture, Plant Pathology, Photography*)

Jewett, D. A., and Dukelow, W. R. 1972. Infrared Photolaparographic Techniques for Ovulation Studies in Primates. **J. Med. Primat., 1,** 193-195. (*Photography, Zoology*)

Johnson, D. R., and Moynihan, R. E. 1958. Infrared spectrophotometry. **J. Chem. Ed., 35,** 76-79.

Jones, B. G. 1957. Low-water photography in Cobscook Bay, Maine. **Photogram. Eng., 23,** 338-342.

Jones, L. A. 1937. Measurements of radiant energy with photographic materials. In: W. E. Forsythe, **The measurement of radiant energy.** New York and London: McGraw-Hill.

Jörg, M. 1938. Über weitere Anwendungen der Ultrarotphotographie in Kriminalistik und Medizin. **Phot. Korr., 74,** 148-150.

Kantor, B. R. 1955. Infrared motion-picture technique in observing audience reations. **Soc. Motion Picture & TV Eng. J., 64,** 626-628.

Kaplan, B. 1967. Under 21. **Life, 63,** No. 5, 38-43, Aug. 4.

Keck, S. 1941. A use of infra-red photography in the study of technique. **Technical Studies, 9,** 145-152 (*Fogg Museum of Art*).

Keene, G. T. 1967. **Star gazing with telescope and camera,** 2nd ed.. Philadelphia: Chilton Co. and Amphoto.

Klingner, F. E. 1934. Erfahrungen bei Mikroaufnahmen von kohlenden Unschlitten mit ultraroten Strahlen, **Mintan. Rund., 26,** 1-4.

Kraft, P. 1932. Neue optische Wege in der Mikrophotographie und Mikroskopie im Dienste der Geologie und Paläontologie. **Z. deut. geol. Ges., 84,** 651-652.

Kuhl, A. D. 1970. Color and Infrared Photos for Soils. **Photogram. Eng., 36,** 475-482. (*Aerial Photography, Agriculture*)

Lanctot, G. H. 1968. Experiments in infrared color. **PSA J., 34.** 16, 19.

Lattman, L. H. 1963. Geologic interpretation of airborne infrared imagery. **Photogram. Eng., 29,** 83-87.

Lawson, R. 1957. Thermography. A new tool in the investigation of breast lesions. **Canad. Serv. Med. J., 13,** 517.

Lawson, R. 1958. A new infra-red imaging device. **Canad. Med. Assoc. J., 79,** 402-403.

Lawson, R. N., and Alt, L. L. 1965. Skin temperature recording with phosphors: a new technique. **Canad. Med. Assoc. J., 92,** 255-260.

Lazarev. D. N., and Ersatov, D. P. 1954. Infrared luminescence in reproduction techniques. **Doklady Aka. Nauk. SSSR, 96,** No. 2, 281-282 (*in Russian*).

Library of Congress. 1954. **Infrared, a bibliography.** Washington: The Library of Congress, Technical Information Division.

Library of Congress, 1957. **Infrared, a bibliography.** Washington: The Library of Congress, Technical Information Division.

Loewenfeld, I. E. 1958. Mechanism of reflex dilation of the pupil; historical review and experimental analysis. **Doc. Ophthal., 12,** 190-448.

Lowenstein, O. 1956. Pupillography. **Am. Med. Assoc. Arch. Ophthal., 55,** 565-571.

Lowenstein, O., and Friedman, E. D. 1942. Pupillographic studies—I. Present state of pupillography; its method and diagnostic significance. **Am. Med. Assoc. Arch. Ophthal., 27,** 969-993.

Lowenstein, O., and Loewenfeld, I. E. 1950a. Mutual role of sympathetic and parasympathetic in shaping of the pupillary reflex to light. **Am. Med. Assoc. Arch. Neurol. Psychiat., 64,** 341-377.

Lowenstein, O., and Loewenfeld, I. E. 1950b. Role of sympathetic and parasympathetic systems in reflex dilation of the pupul. **Am. Med. Assoc. Arch. Neurol. Psychiat., 64,** 313-340.

Malan, O. G. 1974. Color Balance of Color-IR Film. **Photogram. Eng.,** 311-317.

Manzer, F. E., and Cooper, G. R. 1967. Aerial photographic methods of potato disease detection. **Bul. 646 Maine Agriculture Experiment Station.**

Maresh, C. 1953. Infrared photomicrography with the electron image converter tube. **J. Biol. Phot. Assoc., 21,** 14-23.

Massopust, L. C. 1934. Infra-red photography in anatomy; some experimental observations. **Anat. Rec., 61,** 71-79.

Massopust, L. C. 1936a. Use of infra-red plate in photomicrography. **J. Biol. Phot. Assoc., 5,** 20-24.

Massopust, L. C. 1936b. Simultaneous infra-red roentgen photography. **Radiology, 27,** 663-666.

Massopust, L. C. 1952. **Infrared photography in medicine.** Springfield: Charles C. Thomas, Publisher.

Matthews, S. K. 1968. **Photography in archaeology and art.** London: John Baker, Publishers.

Mecke, von R., and Baldwin, W. C. G. 1937. Warum erscheinen die Blätter im ultraroten Licht hell? **Naturwiss., 25,** 305-307.

Merkelbach, O. 1939. Das infrarote Spektrum von Hämoglobin, von Blutfarbstoffderivaten und von Pigment. (Dopamelanin). **Ztschr. Angew. Photogr., 1,** 33-42.

Merrill, P. W. 1934. Invisible starlight. **Science, 79,** 19-24.

Milanesi, Q. 1963. Proposta di una facile metodica ausiliaria per lo studio delle ceramiche di epoca preistorica e protostorica. **Riv. Sci. Preist., 18,** 287-293.

Miller, G. L. 1952. Improved infra-red photography for electrophoresis. **Science, 116,** 687-688.

Mitchell, C. A. 1935. The use of infra-red rays in the examination of inks and pigments. **Analyst., 60,** 454-461.

Mitchell, C. A. 1937. The evidence of inks and pencil pigments. **J. Proc. Inst. Chem. G. B. I., 2,** 150-151.

Mitchell, G. A. G., and Graham, J. B. 1958. Microradiography. **Med. Radiogr. Phot., 34,** 1-13.

Mohler, N. M. 1936. Photographic penetration of haze. **J. Opt. Soc. Am., 26,** 219-220.

Myers, V. I., Ussery, L. R., and Rippert, W. J. 1963. Photogrammetry for detailed detection of drainage and salinity problems. **Trans. Am. Soc. Agricultural Engineers, 6,** 332-334.

Nace, G. W., and Alley, J. W. 1961. On the photography of unstained, differentially stained and fully stained precipitation lines in agar. **J. Biol. Phot. Assoc., 29,** 125-133.

Nomarski, G. 1955. Microscopie dans l'infrarouge. **Rev. d'Optique, 34,** 29.

Norman, G. G. 1965. Infra-red proves useful in disease detection project. **Citrus World, 2,** No. 7, 9-10.

Norman, G. G., and Fritz, N. L. 1965. Infrared photography as an indicator of disease and decline in citrus trees. **Proc. Florida State Horticultural Soc., 78,** 59-63.

Northrop, K. G., Johnson, E. W. 1970. Forest Cover Type Identification. **Photogram. Eng., 36,** 483-490. (*Aerial Photography, Forestry*)

Norton, C. L. 1964. The use of color and infrared film in photogrammetry. **Photogram. Eng., 30,** 423-427.

O'Donnel, W. H. 1975. Infrared and Ultraviolet Photography of Manuscripts. **Papers of the Bibliographical Society of America,** 69, 574-83.

O'Hara, C. E., and Osterburg, J. W. 1949. **An introduction to criminalistics.** New York: MacMillan Co.

Olson, C. E. Jr. 1964. Spectral reflectance measurements compared with panchromatic and infrared aerial photographs. (AD 603 499)

Orsenigo, J. R. 1970. Crop signals with Color Infrared Aerial Photography. **Sunshine State** Agricultural Research Report, 15-6. (*Agriculture, Plant Pathology*)

Parry, J. T. and Turner, H. 1971. Infrared Photos for Drainage Analysis. **Photogram. Eng., 37,** 1031-1038. *Hydrology*)

Pestrong, R. 1969. Multiband Photos for a Tidal Marsh. **Photogram. Eng., 35,** 453-470. (*Aerial Photography, Agriculture, Hydrology*)

Philpotts, L. E., and Wallen, V. R. 1969. Infrared Color for Crop Disease Identification. **Photogram. Eng., 35,** 1116-1125. (*Agriculture, Plant Pathology*)

Plotnikow, J., and Mibayashi, R. 1931. Ausmessungen der Ausbreitung der Warmestrahlen in verschiedenen Tierkörperteilen nach der photographischen Methode. **Strahlentherapie, 40,** 546-561.

Prát, S. 1935. Demonstration of photomicrographs of chromosomes made in infra-red rays. **Zesde Intern. Botan. Cong. Proc., 2,** 24.

Preissecker, E. 1931. Uber Mikrophotographie im infraroten Licht. **Wien. Klin. Wochschr., 2,** 1458-60.

Radley, J. A. 1948. **Photography in crime detection.** London: Chapman and Hall, Ltd.

Rawling, S. O. 1945. **Infra-red Photography.** London and Glasgow: Blackie & Son, Ltd.

Reed, F. C. 1960. Lighting techniques for the photography of agar diffusion plates. **Tech. Bul. Registry. Med. Technol., 30,** 48-50.

Rhoads, D. C., and Stanley, D. J. 1966. Transmitted infrared radiation: a simple method for studying sedimentary structures. **J. Sedimentary Petrol., 36,** 1144-49.

Rohde, W. G. and Olson, E. C. 1970. Detecting Tree Moisture Stress. **Photogram. Eng., 36,** 561-566. (*Forestry, Photography*)

Rieck, J. 1954. Infra-red kinematography. **Med. Biol. Ill., 4,** 89-94.

Rieck, J. 1964. Bild- und Ton-Zeitdehnung. **Kino-Tech., 18,** 277-278.

Rolfe, W. D. I. 1965. Uses of infrared rays. In: Kummel, Bernhard, and Roup, D. M., Eds.; **Handbook of paleontological techniques.** San Francisco: W. H. Freeman and Co.; 345-350.

St. Joseph, J. K. S., Ed. 1966. **The uses of air photography.** London: John Baker, Publishers.

Sewell, J. I., et al. 1970. Infrared Sensing Techniques for Evaluating Soil Moisture Levels. Paper No. 70-343, **Am Soc. of Agr. Eng.** (Aerial Photography, Agriculture, Photography)

Shillaber, C. P. 1949. The use of infrared to show differences in material. In: **Photomicrography in theory and practice,** 4th printing. New York: John Wiley and Sons, Inc.; 594-597.

Simon, I. 1966. **Infrared radiation.** Princeton: D. Van Nostrand Co. Inc.

Somerford, A. W. 1961. Technique of infra-red luminescence photography. **Identification News, 11,** No. 7, 4-6, 10.

Sonne, C. 1929. Investigations on the actions of luminous rays and their modes of action. **Arch. Phys. Ther. X-ray Radium, 10,** 93-103.

Spurr, S. H. 1960. **Photogrammetry and photointerpretation,** 2nd ed., New York: The Ronald Company.

Stellingwerf, D. A. 1966. **Practical applications of aerial photographs in forestry and other vegetable studies,** Series B, No. 36. Delft: International Training Center for Aerial Survey ITC Publications.

Sternitzky, J. L. 1955. **Forgery and fictitious checks.** Springfield: Charles C. Thomas, Publisher.

Strandberg, C. H. 1964. An aerial water quality reconnaissance system. **Photogram. Eng., 30,** 46-54.

Strandberg, C. H. 1966. Water quality analysis. **Photogram. Eng., 32,** 234-248.

Strandberg, C. H. 1967a. **Aerial discovery manual.** New York: John Wiley and Sons, Inc.

Strandberg, C. H. 1967b. Photoarchaeology. **Photogram. Eng., 33,** 1152-57.

Strandness, D. E. Jr. 1967. Liquid crystals monitor skin temperature. **Rassegna, 44,** 16-22.*

Swindle, P. F. 1935. The architecture of the blood vascular networks in the erectile and secretory lining of the nasal passages. **Ann. Oto. Rhino. Laryng., 44,** 913-932.

Tarkington, R. G., and Sorem, A. L. 1963. Color and false color films for aerial photography. **Photogram. Eng., 28,** 88-95.

Tholl, J. 1967. Short wave ultraviolet radiation—its uses in the questioned document laboratory. **Police, 11,** 21-28.

Thompson, M. M. et al. 1966. **Manual of photogrammetry,** Vol. I, II, 3rd ed.. Washington: American Society of Photogrammetry.

Tombaugh, C. W. 1964. Planetary and lunar research in the photographic infrared, visible, and ultraviolet. **U.S. Govt. Res. Rept., 39,** 39.

Treffers, H. P., and Moore, D. H. 1941. The use of infrared film for electrophoretic and ultracentrifugal analyses. **Science, 93,** 240.

Viterbi, E., and Cirolinia, W. 1934. L'opacita differenziale all' infrarosso utilizzata in richerche anatomiche—I. **Mon. Zool. Ital., 45,** 12-17.

Wagman, I. H., and Gullberg, J. E. 1942. The relationship between monochromatic light and pupil diameter. The low intensity visibility curve as measured by pupillary measurements. **Am. J. Physiol., 137,** 769-778.

Wagner, G. 1965. **Infrarot Fotografie.** Stuttgart: Verlag Die Schönen Bücher, Dr. Wolf Strache.

Wallis, F. G. 1952. Process work by infra-red. **Proc. Engraver's Monthly, 59,** 110-115.

Walton, J. 1935. An application of infra-red photography in paleobotanical research. **Nature, 135,** 265.

Weber, H. 1967a. Exotic emulsions. **Camera 35, 11,** 50-52, 69.

Weber, H. 1967b. A primer on infra-red. **Camera 35, 11,** 64, 79-80.

Wehlte, G. 1955. Gemäldeuntersuchung im Infrarot. **Maltechnik, 61,** 52-58.

Whipple, H. E., ed. 1964. Thermography and its clinical applications. **Ann. New York Acad. Sci., 121,** 1-304.

White, E. E., and Hayes, R. J. 1961. The use of stereocolor photography for soil profile studies. **Phot. J., 101,** 211-215.

Williams, K. Lloyd-, and Cade, C. M. 1964. Pictorial recording of body temperature. **Med. Biol. Ill., 14,** 105-112.

Wilson, R. C. 1960. **Manual of photographic interpretation,** Chap. VII. Menasha: The George Banta Co., Inc.

Wobber, F. J. 1971. Imaging Techniques for Oil Pollution Survey Purposes. **Phot. Applications, 6-4,** 16-23. (Ecology, Photography).

Wolfe, W. L., Ed. 1965. **Handbook of military infrared technology.** Office of Naval Research. Department of the Navy.

*Medical review, English edition.

Wood, R. W. 1910. Photography of invisible rays. **Phot. J., 50,** 329-338.

Woodmansee, W. E. 1966. Cholesteric liquid crystals and their application to thermal nondestructive testing. **Materials Evaluation, 24,** 564-572.

Wulfeck, J. W. 1955. Infra-red photography of the socalled third Purkinje image. **J. Optic. Soc. Am., 45,** 928-930.

Yajima, T., Shimizu, F., and Shimoda, K. 1962. High-speed photography using a ruby optical laser. **Appl. Opt., 1 (6),** 770-771.

Zyushkin, N. M. 1960. Photography of luminescence in reproduction techniques. **Zhur. Nauch. Priklad. Kine., 5,** 274-279 (in Russian).

Other Kodak Publications of Interest to Readers of this Data Book

Eastman Kodak Company supplies over 800 data books and technical pamphlets that provide authoritative, up-to-date technical information about Kodak products and their applications in many fields. These publications are listed in the *Index to Kodak Information* (L-5), and can be obtained from your photo dealer, or may be ordered with the order form contained in the *Index.* You can request a complimentary copy of the *Index* by writing to Department 412-L.

Index